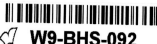

PHOTOGRAPHING CHILDREN IN BLACK & WHITE

Helen T. Boursier

AMHERST MEDIA, INC. ■ BUFFALO, NY

Published by:
Amherst Media, Inc.
P.O. Box 586
Buffalo, N.Y. 14226
Fax: 716-874-4508
www.AmherstMediaInc.com

Publisher: Craig Alesse
Project Manager: Michelle Perkins
Senior Editor: Frances Hagen Dumenci
Assistant Editor: Matthew A. Kreib
Editorial Assistant: Paul Grant

ISBN: 1-58428-014-X
Library of Congress Card Catalog Number: 99-76592

Printed in the United States of America.
10 9 8 7 6 5 4 3

Notice of Disclaimer: The information contained in this book is based on the author's experience and opinions. The author and publisher will not be held liable for the use or misuse of the information in this book.

ABOUT THE AUTHOR:
Helen T. Boursier has operated a portrait studio on Cape Cod since 1983 with her husband of twenty years, Michael. She works exclusively with black and white portraits of families and children. Her trademark look includes lightly hand colored wall portraits on artist canvas. Helen has authored a dozen other photography books, and has lectured on photography across the country and around the world.

Table of Contents

INTRODUCTION . 7

CHAPTER ONE
ILLUSTRATIVE IMAGERY VERSUS TRADITIONAL 9
 Like Attracts Like . 9
 Defining Traditional . 9
 Elements of Illustrative Imagery . 11

CHAPTER TWO
FILM SELECTION — INCLUDING FUN FILM FOR FUN PORTRAITS 25
 Kodak Tri-X Professional . 25
 Infrared Film . 27
 High Speed Film . 29
 Polaroid SX-70 Instant Film . 30

CHAPTER THREE
CHOOSING YOUR LOCATION . 34
 Client Selection versus Your Favorite Locations 34
 Prime Time Lighting . 35
 The Portrait Style . 35

CHAPTER FOUR
PREPARING MOM FOR FABULOUS PORTRAITS 42
 Planning . 42
 Clothing Do's and Don'ts . 43
 Tips for Handling the Unexpected . 47

CHAPTER FIVE
EXPRESSION — CAPTURING THE HEART OF A CHILD 48
 Defining the Timeless Moods . 48
 Getting Parents to Step Aside . 48
 The "Crazy Lady" Syndrome . 51

CHAPTER SIX
WINDOW LIGHT — WORKING IN THE STUDIO AND ON LOCATION 56
 Basic Equipment Requirements . 56
 Timing the Session . 56
 Light Meter Reading Usage . 57
 Using Windows On Location . 60

CHAPTER SEVEN

STUDIO LIGHTING OFFERS QUALITY CONTROL. 61
 Equipment List . 61
 Practice Makes Perfect . 61

CHAPTER EIGHT

AVAILABLE LIGHT PORTRAITS ON LOCATION. 70
 Looking for Ideal Lighting. 70
 Variables in Outdoor Photography with Natural Light. 70
 Eyeing Up a Location . 75
 Controlling Light by Controlling Time of Session 75
 Working with Inclement Weather . 76

CHAPTER NINE

TIPS FOR PHOTOGRAPHING TOTS TO TEENS 80
 Defining the Ideal Age for a Child's Portrait 80
 The Difference Between Boys and Girls. 80
 Baby Portraits. 81
 Toddlers . 83
 Elementary-Aged Children. 84
 Teenagers and Young Adults. 88

CHAPTER TEN

MIXING AND MATCHING — BOYS AND GIRLS IN GROUPS 91
 Working with Different Ages and Different Sexes within One Group . . 91
 Cousins — the Ultimate Challenge. 99

CHAPTER ELEVEN

SOLVING SPECIAL PROBLEMS — TWINS, PETS, HANDICAPPED. 106
 Photographing Twins and Groups of Small Siblings. 106
 Adding the Family Pet to the Portrait. 110
 Working with Special Needs Kids . 112

APPENDIX

 Supplier's List . 116
 Equipment List . 118
 Additional Reading List. 119
 Glossary . 120
 Index. 121

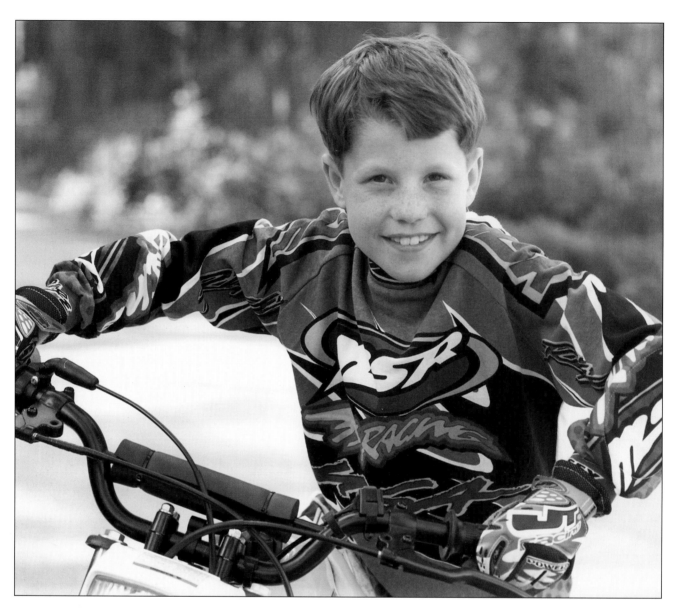

DEDICATION:

When I photographed this energetic boy in May 1996 as a surprise for Father's Day, he was the picture of health. He died in December 1996 from complications of the illness he was born with, cystic fibrosis. Kevin was ten years old. His portrait reminds me that life is short and that I should put forth my personal best with every portrait I create. I dedicate *Photographing Children in Black & White* to the memory of Kevin P. Williamson.

INTRODUCTION

Black and white photographs hold a timeless appeal that remind many of us of our childhoods. I have had many clients commission portraits because they loved the black and white portraits of themselves (or their parents) as children and they wanted something similar of their own little ones. It gives them a sense of connection to their heritage to have a portrait of their own children in black and white.

Oddly enough, while the majority will choose the black and white image because it is timeless, others choose the medium because they define it as contemporary and different.

Professional photographers hold this viewpoint too. When I lecture during the winter months at professional photography conferences across the United States and around the world, I have had many photographers tell me they don't offer black and white because they feel it is simply a trend that will burn out quickly.

While black and white portraiture may be new for those who have never been photographed in black and white, it is a "trend" that is here to stay.

Grandpa Taylor gave me my first camera as a Christmas gift in 1968. I promptly brought the instamatic camera with 126 cartridge film to my third grade class at Riverside Elementary School in Wichita, Kansas for "show and tell," and I have been photographing non-stop ever since.

I once commented to my life-long best friend, Tootie, that I don't know how I ended up a full-time photographer when I actually set out to be a full-time writer. She reminded me that if it hadn't been for my constantly snapping pictures where ever I went, she would have no photographs of her childhood. Until that moment, I never put two and two together. I thought everyone took pictures everywhere!

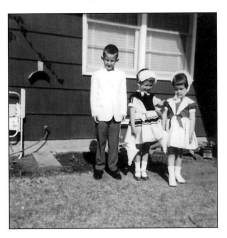

Black and white portraits remind many of us of our childhoods. This Easter morning snapshot of my brother Jim, my sister Nancy (middle) and myself was taken in 1963.

The first black and white photograph I ever took of children was of my third grade class at Riverside Elementary School in Wichita, Kansas. It was just a few days after Christmas vacation and I wanted to use my new camera.

When our son, Jason, was born on January 19, 1981, I began recording his life with black & white film. I used Kodak Tri-X film in a 35mm camera and processed and printed the film in a make-shift darkroom in our basement.

I never realized the ten years of photographing in black and white as a child led to the twenty years I have photographed as an adult. Other than a handful of years in the middle, all of my portraits have been created in black and white.

While most of my clients are drawn to the timelessness, and a few are drawn to the novelty, I am drawn to the sheer beauty of the grey tones. I also love the way black and white portraits draw the viewer's eye right to the expression of the subjects in the photograph.

Jason's junior high portrait is one of my all-time favorites. It is also an excellent example of the difference between color and black and white. As is, the first element you notice is his expression. If the same image was photographed with color film, the first elements you would notice would be the vibrant blue of the water and sky and the green grass. It would be a beautiful environmental portrait, but the environment would have more impact than the subject.

Your eye is not distracted with the color of the clothing or the blue of the sky or the green of the grass. Instead, you see the sparkle in the eyes, the tip of the head, the dimple in the cheek and that perfect expression of the mouth.

Photographing Children in Black & White is not about beautiful backgrounds but about beautiful portraits of regular children.

As I write the words for this introduction on the morning of our son's eighteenth birthday, I am poignantly aware of the value of portraiture. How much would I or could I remember without the volumes of photographs?

When all is said and done, the portraits make time stand still. They remind me of the many precious moments that have filled the past eighteen years of parenting Jason. Without the photographs, I am not sure just how much I would remember.

> "When all is said and done, the portraits make time stand still."

My goal with every portrait is to photograph the sparkle and spirit of each child. If you, the viewer, can look at these images and say, "Wow! You really captured the essence of that child," then I have created a portrait that is invaluable to the mothers and fathers of these children. I hope this book helps you to do the same.

Enjoy!
Helen T. Boursier

CHAPTER ONE
ILLUSTRATIVE IMAGERY VERSUS TRADITIONAL

Like Attracts Like

Since "like attracts like," the style of your photographic imagery ultimately determines which clients come to you and which go elsewhere.

The most noticeable element of style is whether the subjects are looking directly into the camera, or if the children are engaged in an activity with each other or with the environment for an illustrative image.

Some photographers offer only one style, while others offer both looks and leave it up to the client to choose.

Defining Traditional

Since the majority of my clients expect me to photograph their children looking directly into the camera, they want to see the faces of their children, not their backs or the sides of their heads. To these clients, looking right at the camera is "normal."

I call this style "traditional" because, by definition, traditional is what we are comfortable with because it is "normal."

When they initially call to inquire about having their children photographed, most clients assume you will photograph the faces of their children shining brightly back at the camera.

The subjects don't necessarily need to be sitting stiffly on a posing chair in the studio. They could be holding hands at the edge of the ocean, standing in a field of flowers or sitting on the ground giving each other a big hug.

The expressions could be soft, serious, laughing, shy or pensive. As long as the subjects are engaged with the viewer, and therefore the photographer, I know I will have fulfilled my client's wish for the image to be "normal" or traditional.

When I am photographing the subjects facing the camera in a traditional style, I basically position the children where I want them within the grouping and within the setting. Then, I engage them in a

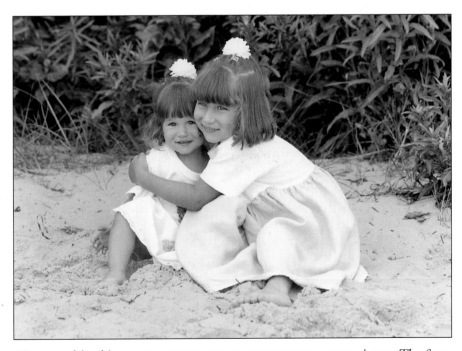

Hugs and/or kisses are a great way to capture two young sisters. The faces are coming right toward the camera, but the feeling is very relaxed and natural.

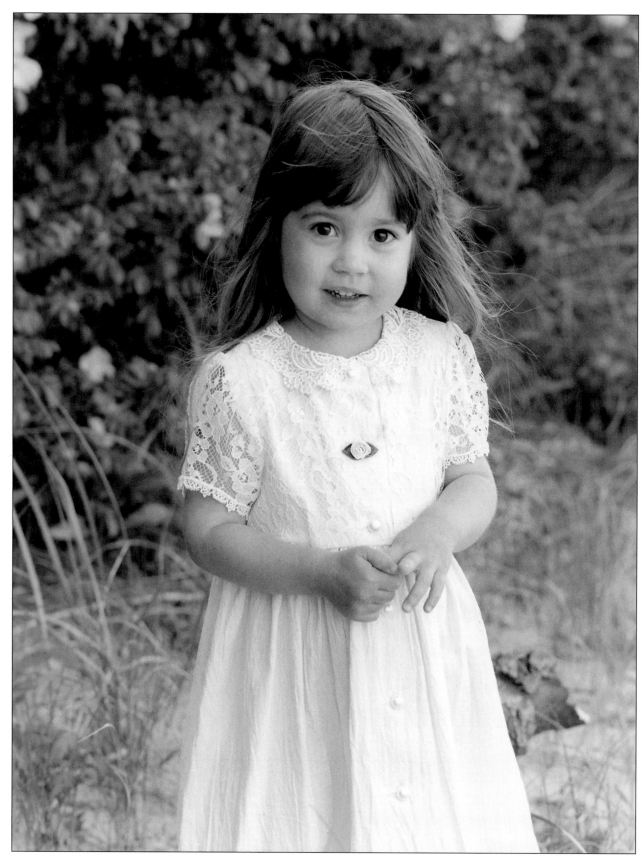

This simple traditional style engages the subject with the viewer. There are no distracting elements in the background that could detract from the little girl's soft expression. The feeling is timeless.

running commentary that varies with the children's ages and the number in the group (see chapter nine). I can easily have a series of awesome expressions within five minutes of starting the session.

Elements of Illustrative Imagery

Illustrative images use the subjects and the environment to tell a story. The subjects are not looking at the camera but are engaged in an activity with each other or with the environment.

Where a traditional portrait engages the subject with the viewer, the best illustrative images make viewers feel like they are looking out a window, watching children play. While my clients call this "candid," I call it "casually perfect."

> "... viewers feel like they are looking out a window, watching children play."

Successful illustrative images look easy, but they are actually much more difficult to design and photograph than the faces-to-the-camera traditional style.

It is very much like when you watch the Olympic athletes. The gymnasts or skaters who score the perfect "10" are the ones who make it look easy.

The reality is that a lot of practice, time and planning went into each routine long before it was performed before the panel of judges.

Setting up the illustrative image requires the same pre-planning before the session and the same concentration during.

Pre-planning begins when you talk with the mother days or weeks before the session (see chapter four). When a mom says she wants something more "candid," I show her examples of the illustrative style.

It is important to show her the style differences because sometimes she is saying candid when she really just wants a traditional look that is relaxed and natural. Once I know we are talking the same language, I will ask her for suggestions on what she wants her children to be doing in the photograph.

Sometimes clients have specific ideas that we plan out in careful detail weeks before the session, and others tell me to "do my thing" the day of the session. Both variations have their strengths and weaknesses.

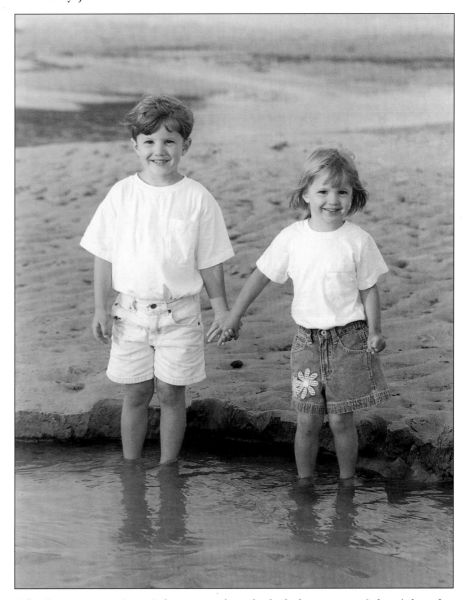

The faces are coming right at you, but the body language of the girl makes you feel the animation in this image.

When mothers pre-plan everything in detail, they usually bring wonderful props and wonderful clothing. The down side is they might bring a less than desirable prop. Also, they might have such strongly pre-conceived concepts that there is no room left to go with the flow as the session unfolds.

On the other hand, when mothers leave the design of the illustrative images entirely up to me, I really have to put my thinking cap on to come up with activities that are suitable to the subjects and believable within the setting. Because my studio is located on Cape Cod, I photograph primarily at the beach. Whether you photograph at the beach, a city park or your client's back yard, you absolutely must make the illustrative images look believable.

Although you might carefully position the children and then direct them to do a certain activity (often over and over and over until you get the image just right), the end result should leave the viewer feeling like the photographer just chanced upon the children doing a particular activity.

The following gallery of images will help you understand the thought process behind designing the illustrative image. You will gain ideas on working with individuals versus groups and boys verse girls. You can easily adapt the ideas to any pretty setting and come up with the same results.

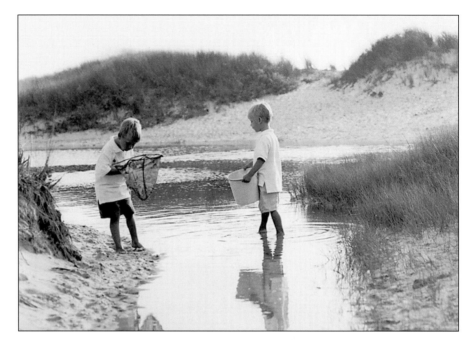

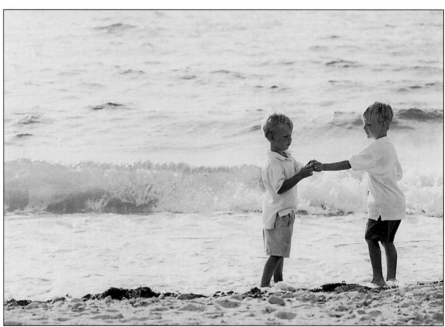

The best way to keep two active boys willingly participating is to engage them in an activity they are genuinely interested in. The mother brought the nets, and the boys searched the flooded area of the beach at high tide for hermit crabs and small fish (top photo). Once they tired of fishing, we went down to the shore where they gathered rocks to skip on the ocean (bottom photo).

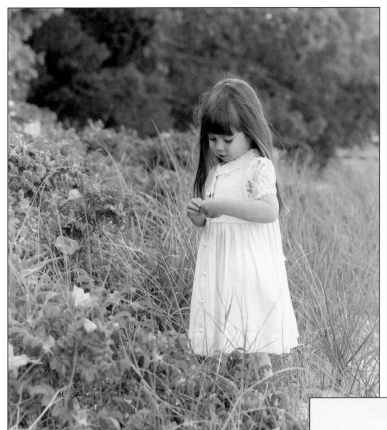

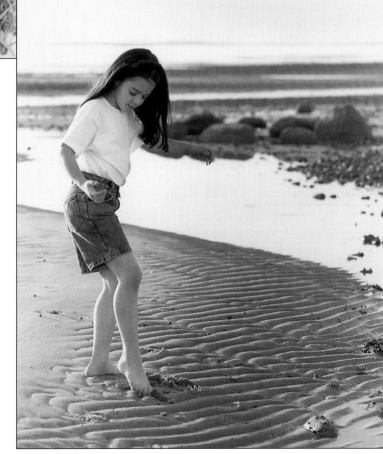

Above: Small hands make an intriguing focal point for an image of an individual child. Since you cannot use another child as the point of interaction, you must use something in the environment. I like positioning pretty little girls in pretty little dresses with flowers. It is a very believable image for her to be picking or holding rose petals.

Right: Older kids need an older look. I asked this child to draw her name in the sand with her toe.

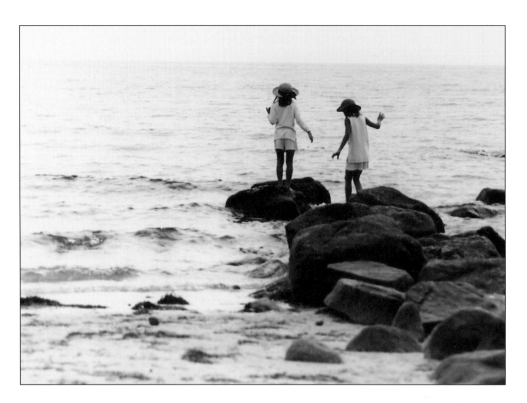

Above: Some mothers come prepared with two outfits and two concepts because they just can't decide. It puts a lot of pressure on me to decide on the spot which is the "best" concept. Since I don't want to be responsible for forcing them to make a decision that they might later regret I always photograph both looks. I follow my gut instinct and take the most images of the style I feel the mother prefers, with only a handful from the "runner up" look. Here, the children arrived wearing summer shorts, but the mother brought two gorgeous dresses the girls had worn in a recent wedding. I took a few images to captures the fun and freedom and energy of playing on the beach, and the rest of the session I had them wear the flower girl dresses.

Right: You need to have a reason to photograph the backs of your subjects. Even though you cannot see the faces of the children, the viewers need to feel like they understand what you are trying to portray. Here, the two sisters are looking at the boats in the harbor. I positioned them so they were close together, and then I asked them to count the boats.

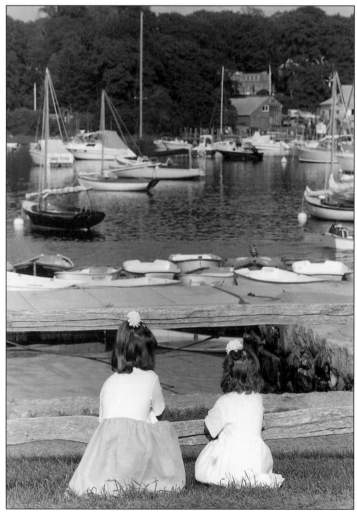

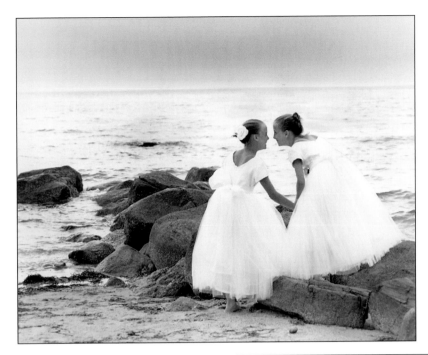

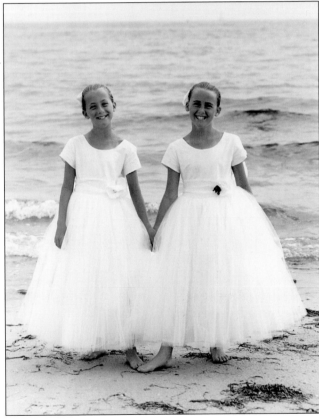

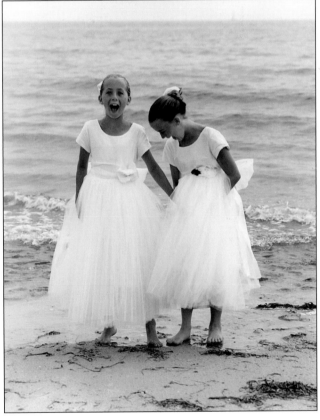

This series represents the typical way I blend traditional and illustrative images within one session. To keep the basic pose from looking static, I ask the girls to hold hands and to make their big toes touch (lower left). The beginning images are more "normal." Then, as my animated chattering gets the girls to giggling, I take another image that captures the relationship the two sisters have toward each other (lower right). The third phase is to change the pose and background and get the girls doing something believable for the dresses they're wearing. Throwing rocks or gathering seashells would not be appropriate, so I had them tell each other a secret, creating an animated feeling and great expression (top).

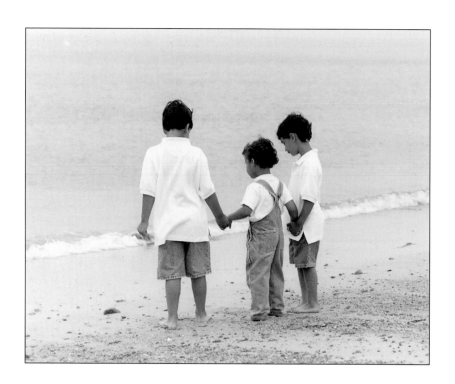

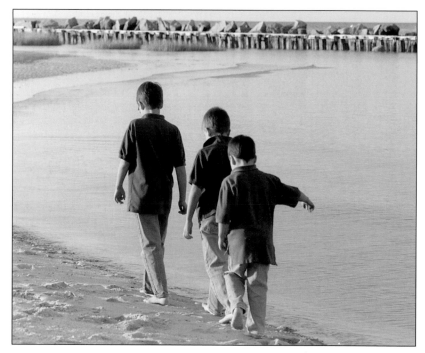

Top: This image doesn't quite work. It is sweet to see the back of the toddler's overalls, but the there is no motion, no feeling of animation, no sense that the boys are interested in either the environment or with each other. The majority of the session was spent photographing faces, and I took a handful of illustrative images just for variety. The mother chose her wall portraits from the traditional series, and I gave this pose to her as an add-on freebie.

Bottom: Follow the leader is a great activity for three or more children. You control the composition, and the body language of the children adds motion and feeling to the image.

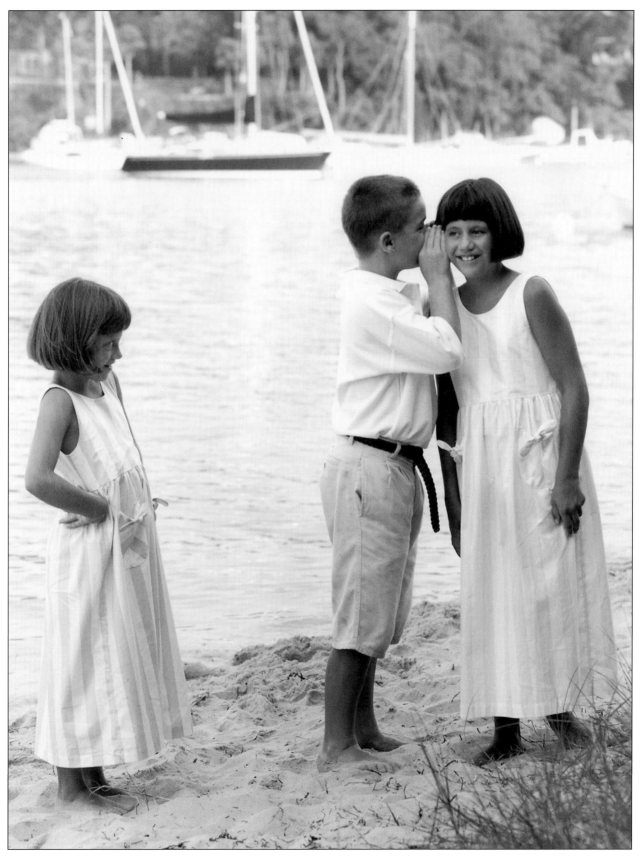

These three cousins actually created this image. Near the end of the session, they said they wanted to take a picture with one telling a secret to another. The younger sister does a great job getting into her role as being on the outside of a big secret!

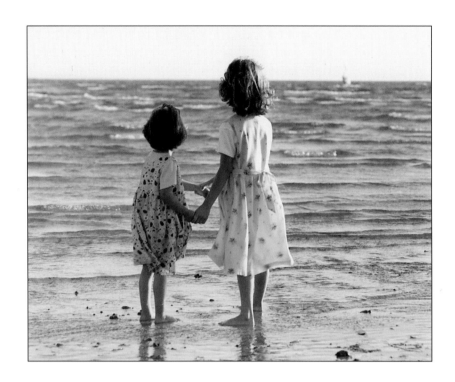

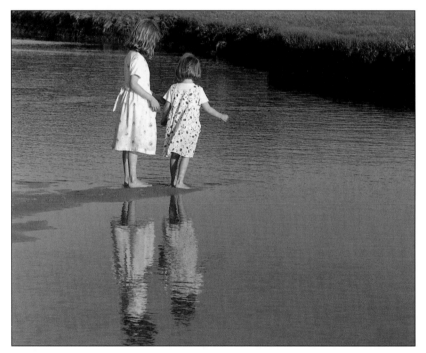

Top: The pose of the two girls looking at the sailboat is my least favorite of the series because the body language is not quite right. I also don't like how harsh the horizon line is going right through the oldest girl's head. To correct the pose, have the girls drop their hands farthest from the camera and ask them to touch their toes on one foot. A higher camera angle would correct the horizon line.

Bottom: This pose is more believable because it looks like the girls walked to the end of a sand bar and then stopped to look for fish, which is exactly what I asked the girls to do! The reflection adds design interest.

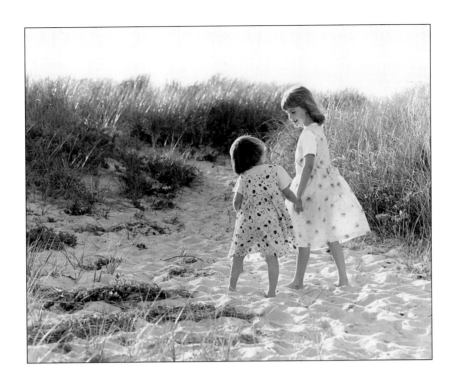

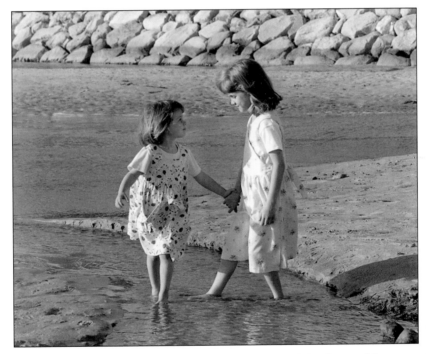

Top: I like this pose the best of the three back poses because the position of the feet and legs match the activity. The girls are holding hands and singing the ABCs.

Bottom: A safe way to do an illustrative image is to photograph the front sides of both girls. The pose is similar to the top photo, but the parents can now see both faces.

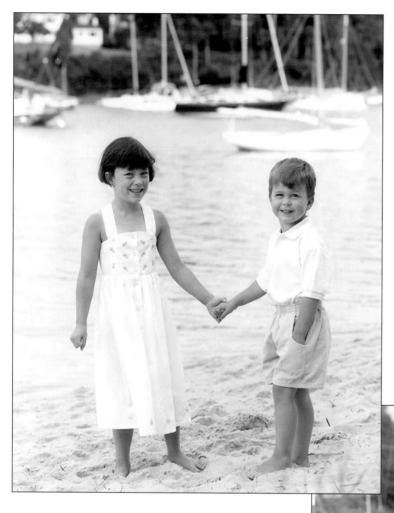

It makes great combination grouping when you create one "faces" image and one illustrative. The pose of the brother and sister holding hands(above) engages the viewer, and the image of them on the rock looking at the hermit crabs (right) captures a candid slice of life.

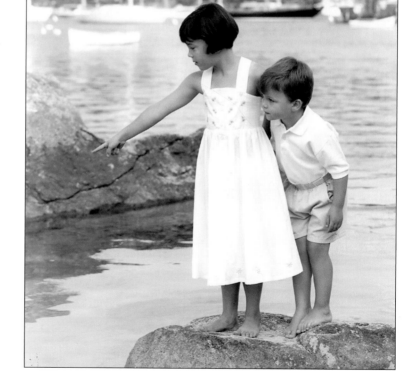

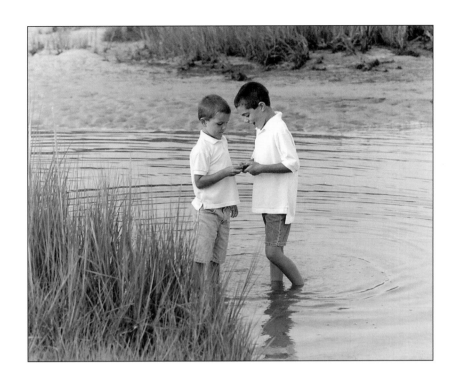

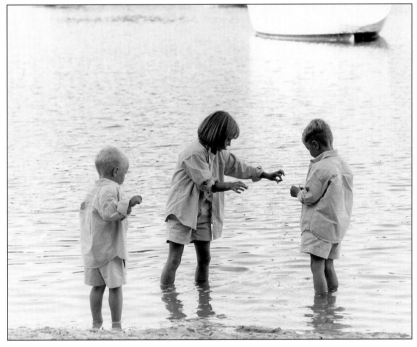

Top: The activity of two brothers must be more specific than for two sisters. Boys this age play hard. They want to throw rocks that make a big splash, and they are not interested in singing a silly song or picking flowers. Here, the boys are comparing who found the biggest rock.

Bottom: Candid looks for three or more children are much harder. First you must think up something for the kids to do that all the ages are able to participate in. Then you must get the bodies and heads in a coordinated direction so it looks like they all want to do what you are setting up. These siblings are picking hermit crabs out of the water and comparing who can find the biggest. The toddler is afraid to touch the hermit crabs, but he is just interested enough to watch what the big kids are doing.

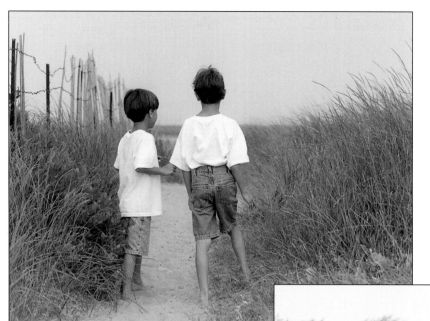

Left: If you are working in low light or if you know you have two very fast runners, you can take the image just before you say "go!" The image captures the feeling of anticipation, but you guarantee it is also in sharp focus.

Below: When you are working in lower light, the slower shutter speed will make the images blur, enhancing the feeling of motion. This image was taken at ¹⁄₆₀ second at f8.

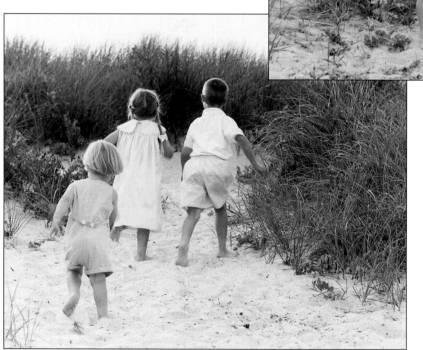

Left: Having the kids run down a path or over a sand dune is a great way to photograph two to four subjects in an illustrative style. I draw a line in the sand and tell them it is a race to see who can get to the top first. Since it is a race, they know there is one starting line and that they cannot start running until I say go. This gives me a chance to set up the image and then get back to camera angle. This image was taken at ¹⁄₁₂₅ second at f11.

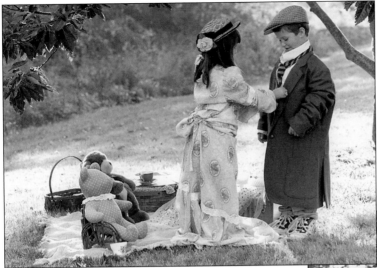

"Getting Ready"

This tea party series was designed by the mother to capture the memories of her childhood with those of her daughter. The dress and the tea set and the props all hold special meaning to the mother. She included her daughter's best friend and favorite stuffed animals. With so much thought put into the design before the session, it was easy to orchestrate a series of realistic poses around the props.

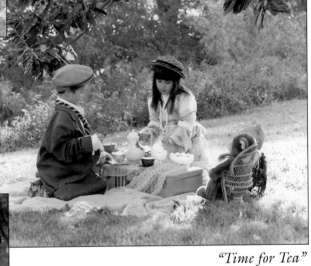

"Time for Tea"

"Cheers"

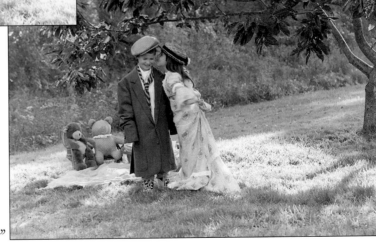

"Thanks for a Lovely Afternoon"

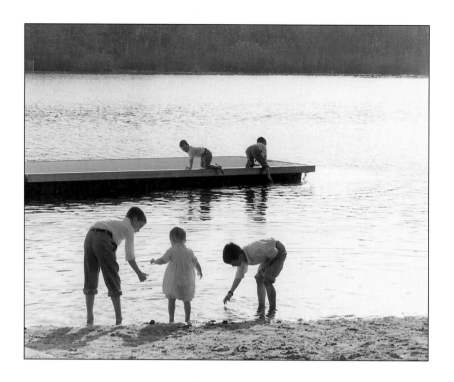

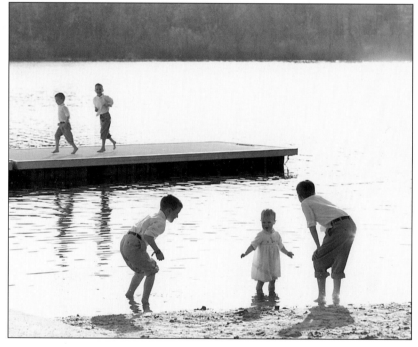

The larger the group, the more difficult it is the gain the cooperation for a carefully posed, but unposed looking, portrait. I enlisted the help of the two older brothers to find rocks to interest the baby while the two middle brothers did their own thing in the distance. The portraits capture the energy and excitement of the unseasonably warm April day and the "spring fever" the boys all caught!

CHAPTER TWO
FILM SELECTION — INCLUDING FUN FILM FOR FUN RESULTS

Kodak Tri-X Professional

My universal film of choice is Kodak Tri-X 320 professional. Kodak rates it at 320 ASA, and I find that dependable in all lighting situations.

I prefer the 220 format (20 exposures on a Mamiya RB67 camera or 24 exposures on a Hasselblad) because I want to

The obvious choice for available light photography beside a window is Tri-X. The exposure was ¹/₃₀ second at f8.5, which allowed me to get a tack sharp image with excellent depth of field and soft lighting that literally wraps around this toddler.

Tri-X works well with a broad range of situations including recording both the strong highlight to shadow range on this backlit image taken at sunset.

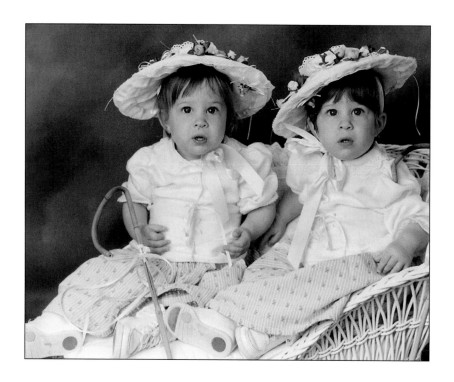

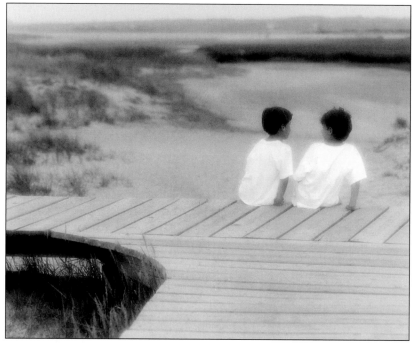

Top: Tri-X also works well for studio portraits. The skin tones record evenly, and the faster ASA (i.e. compared to using Kodak Plus-X or Kodak Verichrome Pan which are both rated at 100 ASA) allows me to photograph at f11 for greater depth of field. I also drag the shutter to allow more light to softly fill in the shadows and give depth to the background.

Bottom: A simple way to make your black and white images look a little different is to print one with a Gepe anti-newton glass slide mount. Simply hold the diffused side of the slide mount under the lens while exposing the photographic paper. It works much better to add the diffusion during printing rather than when taking the initial photograph because soft focus filters make black and white film look flat. In-camera diffusion also causes halation, or a glowing effect surrounding the subjects.

When you use Tri-X, you can change the look of your background by not dragging the shutter, creating a darker background and putting more emphasis on the subject.

change rolls of film as little as possible. It breaks the momentum and the spontaneity with my small clients when I stop to change rolls.

I do keep a handful of 120 rolls in my camera bag for the odd times when I need to take "just one more" exposure at the end of a session.

I like Tri-X because of the wide range of lighting situations that the film is able to handle. (All of the images included in *Photographing Children in Black & White* were taken with Tri-X unless otherwise noted.)

Infrared Film

Photographing with high speed infrared black and white film requires an entirely new thought process.

Infrared film records light your eye cannot see, making it more difficult to properly focus and correctly expose each image.

Another major difference is the format available.

Most portrait and wedding photographers prefer Kodak Infrared which is available only in 4x5 sheet film or in 35mm. Since I work with a medium format camera (Mamiya RB67 for groups and Hasselblad for individuals), I must go either up or down in size.

Since a view camera is not the most practical camera for photographing small children, I opt to go down in size to a 35mm Sigma. Kodak rates the film at 50 ASA, but most photographers rate it at 200 ASA.

You need to use a #25 medium red filter in front of the lens for environmental photography, and you do not compensate your exposure for the filter.

Also, remember that infrared film must be loaded in and out of your camera in total darkness.

An important issue to solve before you buy your first roll of

infrared film is where you will have it processed. It is a speciality item that the majority of color labs do not offer.

Your best option is to look for a lab that specializes in black and white or one that caters to commercial photographers. If you have a lab process your film, tape the plastic canister lid closed to ensure it does not come loose during shipping.

> "Your best option is to look for a lab that specializes in black and white."

The easy part about using infrared is the freedom I have with the small format camera. I set my ASA on the built-in light meter to 200 and let the camera factor the exposures. The light meter measures only the visible

Photographed in full shade with Kodak Tri-X Professional film. Compare this photo with the one on the right.

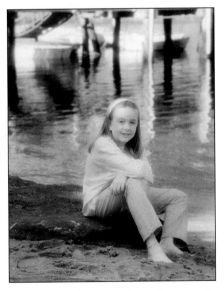

Taken in the same location as the photo to the left, it was photographed with Kodak Infrared, creating an image with a more ethereal quality.

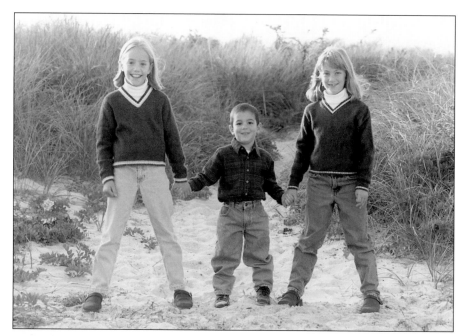

Closer up images are more diffi-cult to focus correctly because there is less room for error. Notice in the photo above how the infrared film eliminated the poison ivy marks on the girl's skin that are very notice-able with the Tri-X film in the photo below.

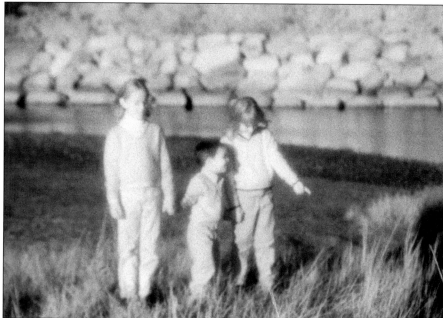

It is easy to focus under adverse conditions, like backlighting, with Tri-X Professional film (top). Bright sunlight that should make focusing easy is challenging with infrared (bottom) because you have to guess at the correct focus. Notice how different the grey tones look. These two images are almost opposites with light sand and dark clothing on the Tri-X image and dark sand and light clothing with the infrared.

spectrum and only approximates the amount of infrared in a partic-ular lighting situation.

Consequently, it is important to bracket your exposures plus and minus one full stop. (If you have to guess, on a sunny day start with $\frac{1}{125}$ second at $f11$.)

In addition to "guestimating" your exposures, you also have to estimate your focus, since infrared film records light that your eye can-not see. Your camera lens should have a small red dot or an "R" on one side of the focus line indicator. You focus on your subject and then twist slightly to line the red dot up with your focus line indicator.

When you first start experimenting with infrared film, you will find it easier to work with older children who sit still because you will constantly focus, stop, look at the lens, then bring the camera back to your eye to take the image.

Gradually, you will feel where you need to twist the camera to,

Above: Infrared film makes green foliage turn light, making it easier to handcolor should your clients request a tinted portrait.

Below: Water generally becomes a deeper grey tone with infrared film, making it difficult to handcolor.

and you will get the majority of your images in focus. The closer you are to the subject, the more difficult it is to focus tack sharp. There is more room for error with full length or pictorial images. The general rule of thumb is you want to focus back closer to the camera about twenty percent. If your visual focus is ten feet, you would set the lens to eight feet when using infrared film.

High Speed Film

High speed film creates another unique look because it adds a grainy texture to every image. It also enables the photographer to hand hold the camera in very low light conditions, reducing

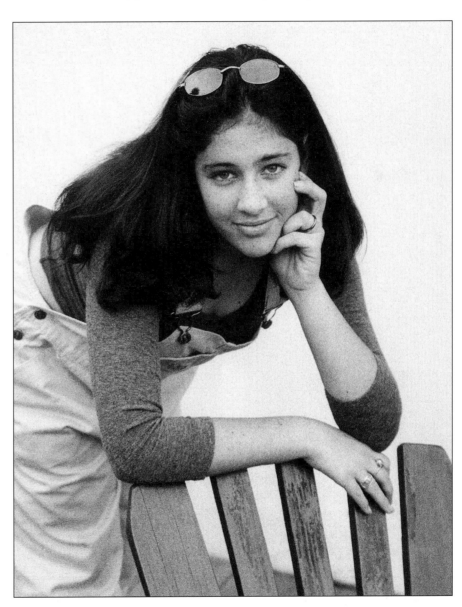

When I photographed my niece in California at Christmas, the high speed film and 35mm camera gave me freedom of movement and flexibility to shoot in a low light situation. I tucked my niece in the heavy shade beside my mother-in-law's house, and easily hand held the camera for an exposure of $1/125$ second at f11.

or eliminating the need to use a tripod. Kodak Tmax 3200 TMZ black and white film is available only in 35mm format.

I use the 3200 film when I want the freedom to leave my tripod at the studio, usually when I am traveling on an airplane and I am trying to pack as light as possible. Photographers who shoot with the high speed film on a regular basis most commonly use it at weddings as a supplement to their medium format color photography. The small camera and high speed film enables them to blend into the background as they take available light candid images.

The high ASA makes the film most useful for low light situations, but you can also use it during the bright light of mid-day. The fastest shutter speed on most modern cameras is 2,000 with a maximum f stop of 22 or 32.

> "The high ASA makes the film most useful for low light situations."

To use the 3200 film in bright light, you need to use either a polarizer or red filter because either filter will cut your exposure back two full f stops.

Or, if you just want to cut your exposure back one stop so you can adjust your f stop to reduce your depth of field (how much of the image is in focus), you use a yellow filter.

Even with using these filters to cut back your exposure reading to a lower (and slower) shutter

speed, you will still be able to use the 3200 film without a tripod. All you need is a steady hand.

Polaroid SX-70 Instant Film

Polaroid SX-70 instant color film is an unexpected way to create one-of-a-kind black and white images. I introduced "watercolor portraits" when I photographed our son's "Class of 1999" classmates. It is an interesting combination of the old with the new for a one-of-a-kind look that intrigues clients.

Basically, I took three to five images with an old Polaroid cam-

era that takes SX-70 Time Zero instant print film.

Once I was back at the studio two or three hours later, I placed the images on a large light table to allow the emulsion to soften slightly. Then I used a series of blunt instruments to smear the emulsion. My favorite instrument is a dowel rod that a photographer friend sharpened to a blunt pencil finish. I also use a golf tee or the rounded side of a paper clip.

Once I am satisfied with the manipulated image, I transfer it to the modern phase of the process. My husband and partner, Mike, scans the image into the computer.

Once you scan the SX-70 image into your computer, you can choose to output onto traditional photographic paper or onto watercolor paper. The grey tones were reduced in the computer to create an almost lithograph effect, and the watercolor paper added to the artistic presentation.

Above: If the sun is too bright to look at, but the light is not too harsh to create unflattering shadows across the face, I will have the subject look off camera.

Right: Broad light right into the face of the subject is ideal for creating the SX-70 watercolor image because the features of the face are not distorted from shadows. This high school senior's dark hair makes her facial features look particularly stunning for a black and white portrait.

Photographing in the late afternoon light is risky because it is difficult for the camera to guess the correct exposure. You need the camera to read the light off of the subject's face, but it "wants" to record the brighter light off the background. To get it right, it takes a little experimenting with the small dial on the front of the camera that sets the exposure from lighter to darker. The trick is to get the correct exposure with the best expression.

Changing the camera angle to the background can add variety and design to an SX-70 watercolor image. With the sun to the subject's left, it creates a strong shadow within the composition of the basically square format SX-70 image. That harsh shadow is easily cropped out for the finished portrait.

Then he can either download the images to a computer disk to send the file to a lab or he can output directly onto watercolor paper.

Most photographers prefer to work in bright, contrasty light when they are creating SX-70 images.

They say the harsh light creates the lines that make the print more interesting. The same harsh light that creates shadows in the background also does a number to the faces of your subjects. The bright light causes your subjects to squint.

I prefer to photograph in the bright shade of late afternoon or with the broad light straight into the faces once the sun is soft enough for the subject to look directly at the camera.

CHAPTER THREE

CHOOSING YOUR LOCATION

Selecting the location for your portrait sessions depends upon several variables.

The choice is ultimately a combination of what the client desires, where you enjoy photographing, what settings are available, the time of day for the actual session, and whether the client wants a formal or an informal mood.

Client Selection versus Your Favorite Locations

During my early years as a professional photographer, I allowed the client's choice of location to be the number one consideration. On the surface, it looked like I was an amiable photographer who wanted to please my clients.

However, the reality was that many times the client's choice was not the best choice. I was grateful to have the work and I did not have enough confidence (or experience) to steer the client to a better location.

For example, it is particularly common on Cape Cod for every person to have a favorite beach that they fondly refer to as "our beach." There were many times I arrived on location to discover it

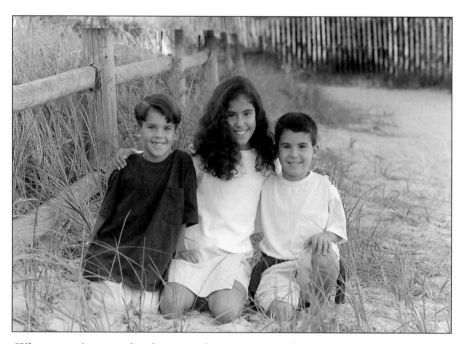

When you frequently photograph at a particular location, you will soon learn how to use every square foot of the setting. I took this photograph, for example, on a windy day in September in the parking lot of a local beach. The dune to the left blocks the wind, and the cars are just off camera to the right.

was extreme high tide with fifteen miles per hour on-shore breezes and a five-foot-high cement wall bordering what was left of the beach. I was left to create my signature look with a less than ideal location.

Now I am much more careful about going to the special locations of my clients. I ask a lot of

questions about the direction of the wind, the direction of the light, what structural elements are in the background (i.e. houses, businesses) and how populated the location will be at the designated session time.

If possible, I will scout the location in advance to make sure the location matches the client's

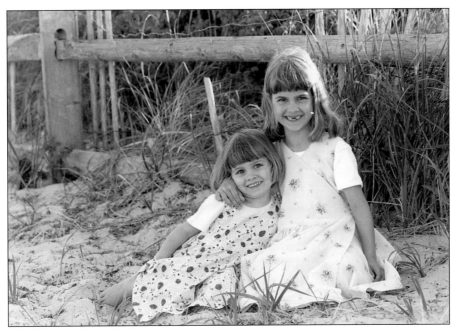

This photo was taken at the same beach parking lot location as the photo on the opposite page, but looking back in the opposite direction. For this image, I used the dune to block the light that was a bit too bright at the beginning of the session. Same beach. Same parking lot. Different challenges from Mother Nature.

A good rule to remember and follow is: if the client chooses the location, then you choose the time; if you choose the location, then the client gets to choose the time. This photo was taken at a client's home — she chose the place, I picked the time.

description. I also show clients many examples of the locations I use on a regular basis, and I explain why these settings work so well for portraiture.

Mother Nature does enough to change the variables from one portrait session to another (i.e. wind strength and direction and light quality).

When I photograph at one of my half dozen regular locations, I know I will be better able to control the end product.

A Michigan photographer has the simple rule that if the client chooses the location, he chooses the time. If he selects the location, then the client chooses the time.

Prime Time Lighting

Time of day makes or breaks an environmental portrait session. The ideal light when photograph-ing out in the open (i.e. the middle of a Kansas wheat field or at the beach) is either dawn or dusk. The light is soft and flattering, making both the subjects and the setting look their very best.

You can photograph literally any location during these two time slots, and you will create beautiful portraits.

The hours in between are much more tricky (hence the Michigan photographer's rule). When Mother Nature does not provide the soft light (i.e. 10 a.m. on a bright, sunny day), you must find flattering light by looking in unexpected places (see chapter seven).

The Portrait Style

The style of the portrait is another element to consider when selecting the location.

Sometimes I choose the setting within the client's suggested location because it has the best quality of light for the time of day. The front of the house was in shade, while the back-yard was very bright. I began the session in the shade to allow time for the light to get a little softer out back.

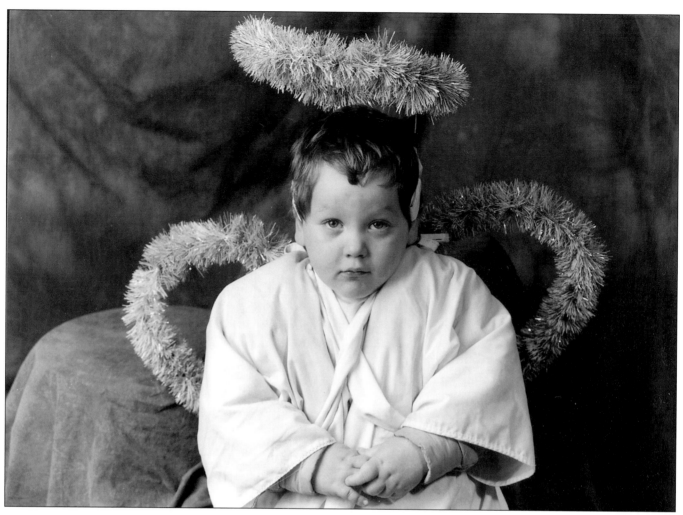

Many clients associate studio portraits with a formal, posed look. However, the real benefit of choosing the simple background is to put the emphasis on the expression and the facial features. The image of this dear little angel has a timeless quality that will be in "style" forever.

Formal portraits are associated with formal settings like the studio or home, but some clients like formal clothing at an informal location. The safest choice is not to assume you know what the client prefers.

"The safest choice is not to assume you know what the client prefers."

Show a lot of different styles within the samples of your printed materials and your studio examples. Then, ask the client to show you which style most suits what she is looking for.

At a seminar I attended in California, the workshop leader had us pair up with another photographer to role play designing a portrait.

"My" photographer ended up designing a high key (white background) studio portrait with my family wearing all white clothing. He never asked me what I

wanted. He just designed it based upon how he normally photographs. It is a good thing the role playing at this seminar did not include a photography session because it would have been a waste of time.

I never would have purchased any of those portraits because I dislike high key and my husband and son never wear white.

Preparing for better portraits begins by preparing clients and listening to what they are telling you that they want.

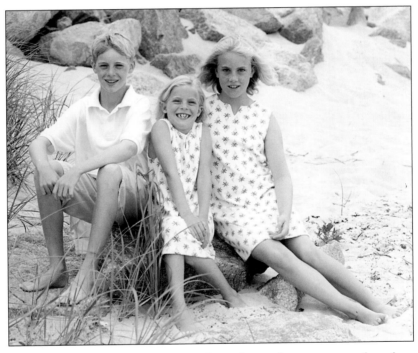

Top: *It is impossible to control Mother Nature. When dense fog and a strong on-shore breeze arrive just before the scheduled session, all you can do is reschedule or scramble to a new location. This client opted to scramble. Since I was an hour away from the studio, it was up to the client to choose the location. We moved to her friend's summer cottage, and I used the beautiful hydrangea bushes as the backdrop.*

Bottom: *Even though we did the house session, I still wanted to get at least something from the beach. The water was completely socked in with fog, and the on-shore breeze blew the soft blond hair, but the portrait at least captured a small slice of summer on Cape Cod.*

This privately owned garden is open to the public. There are hundreds of thousands of daffodils blooming here in April, making it a popular place to visit in spring. The flowers make it breathtaking, but all the trees and structures can make the background too busy for portraits. By working at this location through the years, I have learned how to show off the setting to its best advantage without detracting from the subjects. To keep the focus on the kids, I want to make sure to pose them with their heads surrounded by flowers. I position them so there are no trees, millstones or the bell growing out of their heads.

This is the same garden location as in the photos on the opposite page, but a little later in the season on a sunny day. The speckled light coming through the trees is an attractive mid-morning feature in this setting, and one that can serve as a primary element in portraits. By positioning the subject so the sunlight hits her back, I can control the quality of light on her face. The backlighting adds a dramatic flair to the image.

When the client chooses the location, I choose the time. The only way to photograph out in the open is at dawn or dusk. Even then, if there are no clouds in the sky to diffuse the light, it can be pinpoint bright until the sun slips behind the horizon. The sun was bearing down on the bow of the boat, so I ended up doing most of the portraits at the stern in the shade of the cabin.

When my clients cannot decide between two locations, usually their home or a nearby park or beach, I am happy to photograph at both locations. I start with the setting that will have some flexibility with lighting and background, in this case their home. Then I work to show as much variety within the setting as possible. It would have been easier to create the individual portraits of these two siblings at one location, but it is more interesting to choose two different backgrounds that each reflects the age and personality of the child being photographed.

CHAPTER FOUR

PREPARING MOM FOR FABULOUS PORTRAITS

Planning

Great portraits begin with great planning. It is impossible to create fabulous portraits without first taking the time to answer a few key questions.

Many studios require clients to schedule a planning or consultation session prior to the camera session. Since many of my clients live one to five hours "off-Cape," I mail a packet of planning information.

Whether you talk to the mothers in person, over the telephone or through the mail, you need to help mothers make decisions about style, clothing, mood, location, prices, policies and the products.

You should also let mothers know what to expect the day of the session, including how to better prepare for the unexpected.

The style of your portraiture is often the reason people pick up the telephone and call your studio to inquire about "how much is an 8x10."

If you have one distinct style, you can assume the caller wants exactly what you offer.

However, it is much more likely that you offer several varia-tions of your main style, so you need to talk up these little differences with the callers to help them define what it is about your work that they like.

The mood is another important element to discuss. Do they want posed and formal or semi-posed and relaxed.

My favorite style is what I call "casually perfect." The children are looking at the camera and sitting or standing close together. They look relaxed and the viewer can tell from their expressions that they are having fun.

I also discuss the location choices and the time of day. Again, showing what different locations look like photographed helps clients to decide which look they like the best.

With my long distance clients, I include postcards which show samples of my favorite loca-

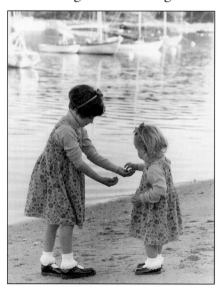

The fundamental question I ask all my portrait clients is whether they want to see the faces of their children or if they want them interacting with the environment (or each other) and not looking at the camera. If they like both styles, I then ask which they like the best. I will do most of the images with their first choice, and a few exposures with their second.

The parents of these children would probably describe this image as a formal pose, but the expressions tell you the children are having a good time.

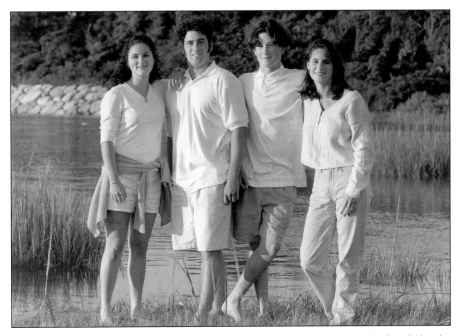

The older teenagers and young adults have a more casual look while the expressions still show that they like each other, and that they are having fun together.

tions. I also include a detailed description of these settings.

Clothing Do's and Don'ts

Clothing suggestions are next on the list of discussion topics. The more examples you can show your clients, the better they will be able to visualize their own end product. Most people think it doesn't matter what colors you wear for a black and white portrait since "the colors won't show anyhow."

The colors don't show, but the tones do. Therefore, the key to getting clients to coordinate their clothing correctly is to talk in terms of tone.

I tell clients to look at all colors as if they were on a scale of one to ten, with one being the lightest and ten being the darkest. The one colors are white, cream, yellow, pink and powder blue.

The ten colors are black, navy, deep purple, maroon, hunter green and red. I tell clients that the objective is to choose colors that are either all light, all medium, or all dark.

The colors can be all dark across the top, with lights on the bottoms (or vice versa), but do not mix some darks on the top with some darks on the bottom because that creates a choppy look to the portrait.

Another issue is stripes verses prints verses solids. Once again, the best way to tell clients is to show them lots of samples.

The idea with clothing is to make it subtle so the portrait calls attention to the faces and not to the clothing.

In general, I tell clients to avoid stripes and prints for group portraits. I tell them that stripes record in black and white as if they took a black magic marker

and drew lines up and down on the clothing. One print dress in the middle of a lot of solid fabric

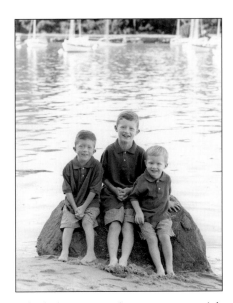

The boys are wearing navy tops with navy and white shorts. The matching outfits make an adorable portrait of these three handsome boys. The clothing also creates a distinct style (compared to unmatched clothing).

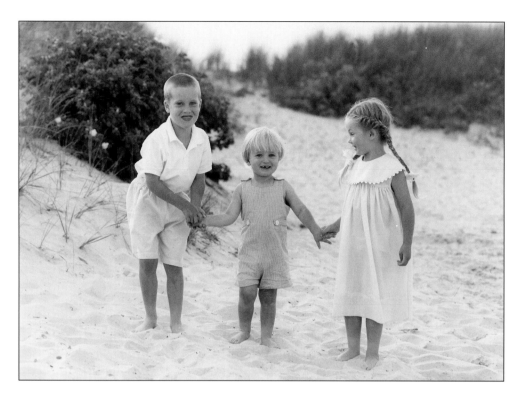

Above: These children are all wearing light clothing. The outfits are complimentary to each other but not identical. It is an excellent idea to have a sample showing both matched and unmatched outfits, so mothers have a strong visual and can decide the look they like best.

Left: The white clothing and the white sand create a classic high key look (white on white). It is easy for mothers to choose which clothing their children should wear when they see samples of several different styles.

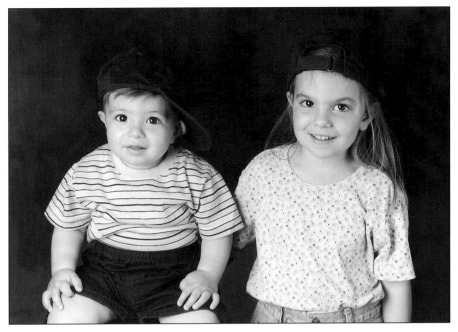

The stripes and prints together in this image create a busy portrait that detracts from the faces.

Compare the photo above to the one on the left. The solid shirts offer no distractions, unlike the stripes and patterns.

calls attention to the one person who wore the print outfit. The point is to help mothers to deliberately select clothing. Then they will love the end results and not say, "Oops!"

Since little girls wear lots of prints and little boys wear lots of stripes, I try to educate clients on what kinds of prints and stripes work well for a portrait. The most important issue is that the choice should be deliberate.

Bold stripes (or large prints or plaids) record very strong while narrow stripes (or tiny prints or gingham plaids) in a pastel color look more subtle.

Very narrow stripes (such as those on seersucker fabric) look almost like a solid when photographed.

Clients should understand the difference, and then choose the clothing based upon their likes and dislikes.

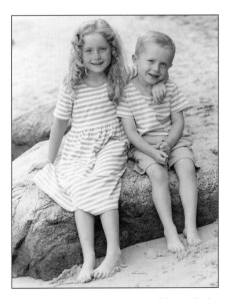

This bold stripe (left photo) in the middle of a group portrait would steal the show, but the outfit makes a bold statement when the toddler is photographed solo. With the photo on the right, the only way to photograph bold stripes in a group portrait is when all the children are wearing the same stripe.

It also helps to discuss props prior to the session. When a client brings a hat, whether it is an infant with a christening gown, a youngster in a bonnet, or a teenager with a baseball cap, I always take some images with the hat on and off. The client might regret the hat once they see the images, so doing both gives a second chance to choose.

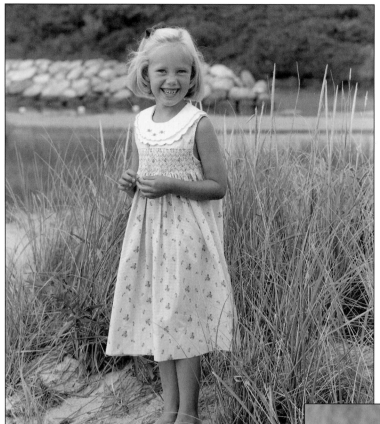

Above: This subtle gingham with its small print is classic little girl and ideal for either an individual portrait or a group portrait.

Right: This bold print outfit suits the toddler's style. The mother deliberately chose these overalls because it was her daughter's favorite summer outfit and because all of the many colors in it would look great with the hand coloring that is part of my trademark style.

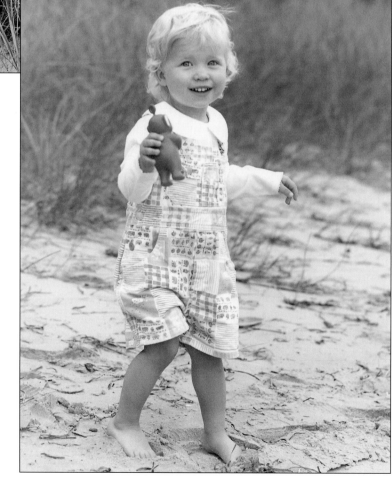

Tips for Handling the Unexpected

My planning session information also presents an overview of my studio policies, the various types of portrait products I offer and the wide range of prices.

The more information clients have in advance, the better they will be able to visualize how to use portraits as personal art in their own homes.

Finally, I review all the decisions made by the client to confirm their choices and make sure I have not left anything out of the discussion.

I also add a few suggestions on how to be prepared for the unexpected. The two critical outdoor elements are wind and bugs. Basically, I tell clients to expect one or the other. When it is windy, hair blows. When it is flat calm, the little "no-see-ums" come out in force at dusk. (These annoying little bugs are attracted to white!)

To make the wind more manageable, I ask clients to tack down any collars that might flap in the breeze.

To combat the bugs, I suggest they apply bug repellent before they arrive at the beach. If they wait until they get to the beach, it doesn't have time to kick into effect.

Of course, I always keep an assortment of bug lotion and bug spray in the trunk of my car just in case.

Clients who are subjected to bugs swear they would prefer a gusty wind, but those who have to fight the wind swear they would prefer the bugs! A little bit

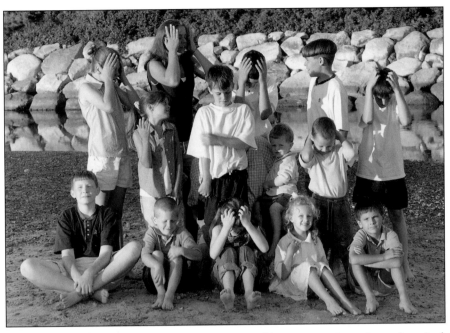

We took an itch break every few minutes at this sunset session where the wind was nonexistent and the bugs were out in force. (The mothers included this image as part of a matted and framed piece of three 11x14 portraits they gave to the grandfather because they felt it would be a great conversation piece.)

 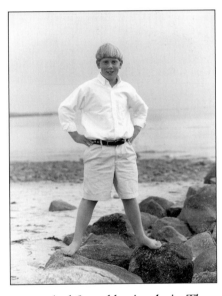

No amount of hair spray can prevent a gusty wind from blowing hair. These boys are brothers. One has hair that blows in the breeze, but the other doesn't. With wind as an integral element of all outdoor portraits, the only options are to duck low behind a dune or house or large bush or to face the subject so the wind goes into the face with the hair blowing naturally behind.

of both is the best combination, but since Mother Nature makes the choice, it is best to come prepared for either.

Make sure you prepare your clients for any challenges that might be unique to your environment and session locations.

CHAPTER FIVE

EXPRESSION — CAPTURING THE HEART OF THE CHILD

The expression is the heart and soul of an excellent portrait. It should tell the viewer a story about the child, and it should be so strong that a total stranger can gain a sense of who the child is by simply looking at the photograph.

Defining the Timeless Moods

Some photographers like to capture only pensive, thoughtful, non-smiling images because they say these expressions are "timeless." I believe laughter, joy and pride are equally timeless moods to preserve on film.

Children, like people of all ages, have different expressions to go with each of their many moods. The "right" expression varies from child to child, from day to day and from mood to mood.

I try to create an image that reflects the true personality of each child, including allowing the shy child to be shy and the wild child to be wild. To me, the true value of portraiture lies in its ability to permanently capture the true essence of our children. If I try to change who the child is, by working to create expressions that are not natural, then I do a disservice to the

parents. Of all of the many details that go into planning a perfect portrait, the one piece I most want to have stick is that mothers allow their children to be themselves. When parents push their expectations upon their children, it is nearly impossible to get expressions which anyone would call natural.

Getting Parents to Step Aside

It is difficult to step aside and not parent (i.e. correct our children) for even the short duration

of a portrait session. I know. Sometimes I have heard things pop out of my mouth as I am photographing our own son that I would never say to a "real client!" I jokingly tell parents up front that it is "against the law" to fuss at their children for anything at any point during the portrait session. Laws are of a higher importance than mere rules, so parents and children get the message that this "law" of mine is very important.

Basically, I want parents to take a break from parenting and to

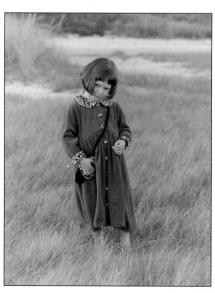 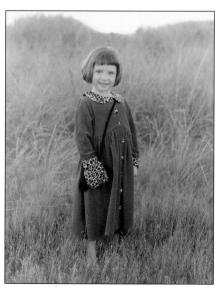

These two photographs are almost a "before and after." One shows the child reacting to being told to "be good" and the other shows her responding to the fun of being photographed. One has parent interaction, and one does not.

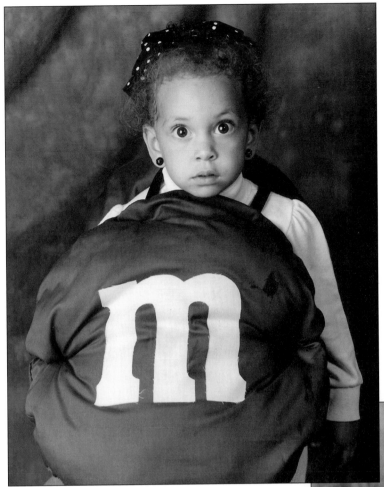

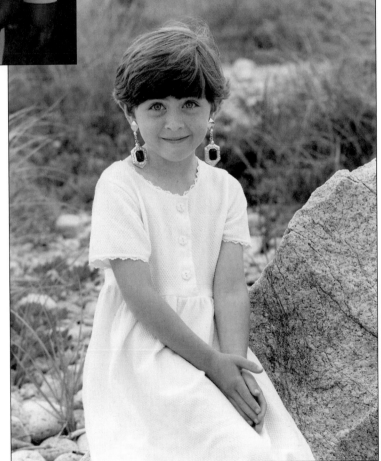

Above: Fear is a natural feeling for a small child coming into a foreign situation like a portrait session. This little "M&M" arrived for a quick portrait session during a Toys For Tots promotion I did on Halloween. Years later, her mother said this image is one of her all-time favorite portraits of her child.

Right: When she wanted to wear her earrings in the family portrait, I promised her I would take one special portrait of her alone, wearing her jewels, at the end of the session. I took several poses of her without the earrings, but it was the one exposure I took with her wearing her treasures that stole the show because you can feel her great pride.

let me do the job for them. All parents understand the logic behind my request, but not all parents can bite their tongues and let me do the talking.

If I can't get the parents not to interfere while they are watching me photograph, my only recourse is to ask them to leave the room or the immediate vicinity at an outdoor session so I can do my job. When mom and dad leave,

> "…not all parents can bite their tongues and let me do the talking."

and there is no one left to say, "stand up straight, don't do that funny smile, sit still, get that hair out of your eyes, stop wiggling," I can get down to the business of capturing the real essence of each child.

When I photographed our son's high school graduation portraits, it was difficult to step aside from being his mother long enough to be the photographer. I had to consciously remind myself to back off and let him be himself.

You have to work quickly with toddlers to distract them from thinking about their parents. They are naturally bonded at the hip with mommy, so you must be particularly silly to get them relaxed.

With older children, I automatically ask the mother to hang out by the car until we are done with the portrait session. I know the kids will respond much better one on one, without mom there to tell them what to do.

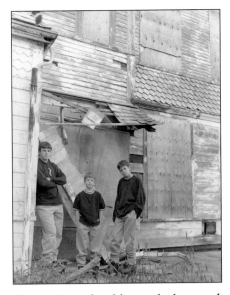

Expressions should match the mood of the image. The theme for these three rollerbladers was "tough turf." The image would look a little strange if the boys were standing up straight and smiling wide for the camera.

Each child has more than one great expression. I love the body language and the sense of self confidence in the photo on the left, and I also love the sparkle and spontaneity in the photo on the right. The parents ultimately chose the one on the right, but it was a hard decision.

Pride is a wonderful emotion to photograph, particularly in a high school senior. This portrait reflects the great sense of self she has for her present, and her future. Letting young adults be themselves is important for capturing the "right" mood.

The "Crazy Lady" Syndrome

My best trick for getting children of all ages to relax is to take over where mom left off when I asked her to leave the photography session. I start in fast and furious to tease and cajole and badger and fuss at the children. One photographer friend calls this his "Bill Cosby mode."

I position the children in a particular location, ask them to do something simple like hold hands or pick up a pebble or pull on a blade of grass.

Then, when they do it too quickly, or perhaps not at all, I talk fast and silly to them. "What are you doing? Did I tell you you could let go of that piece of grass? Where are you going? Why did you let go of your sister's hand? Did I say it was okay for you to take a step? You get back there right now!"

The kids just flat don't know what to make of this crazy lady. In fact, when the mother comes back to look at the selection of images, she cannot wait to tell me the earful her kids gave her all the way home of that nutty lady that screamed at them.

This crazy combination of outspoken and silly enables me to make minor adjustments on both the pose and the expression without the subjects being aware of what I am doing.

Since I work as quickly as possible, they think I have taken one photograph when I have really taken half a dozen. My speed gives me the edge over their short attention spans!

"My speed gives me the edge over their short attention spans!"

51

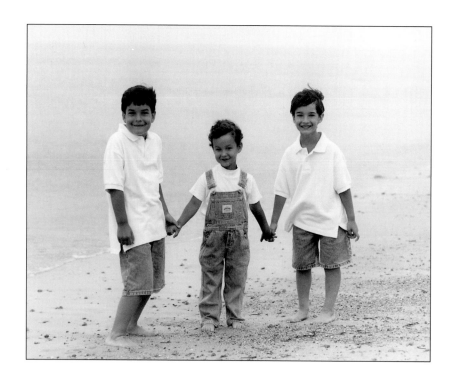

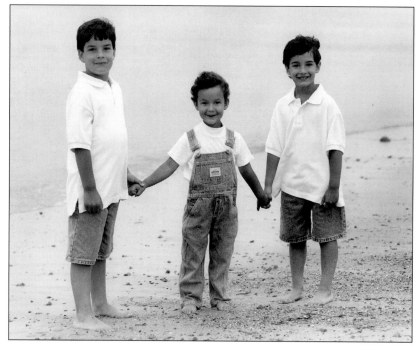

The minor differences between these two images is natural expression (top) verses posed (bottom). One looks like the boys are thinking about how mom wants them to smile. In the other, they are just doing their thing – being boys!

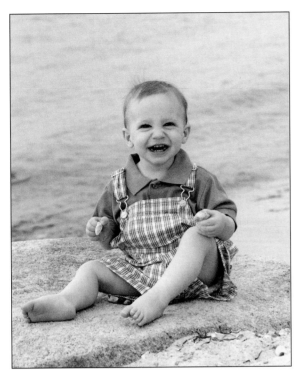 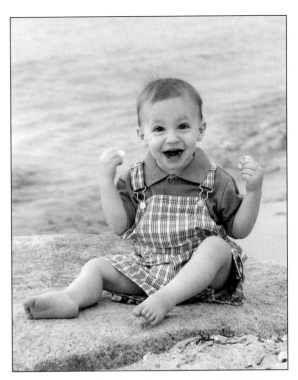

The safe choice here is the photo on the left, but I love the gleeful joy portrayed in the photo to the right. When mothers agonize over the best pose to choose, I know I have done my job. I would much rather create too many images that portray the true spirit of their children, than not enough.

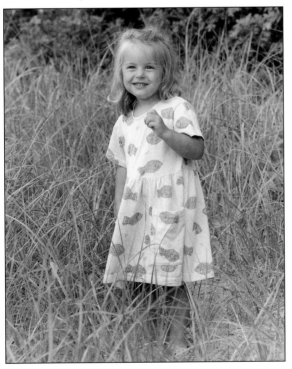 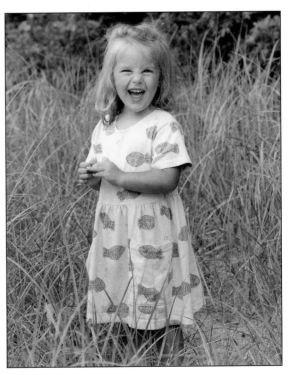

These images were taken a split second apart. The photo on the left is the safe choice because it lends a timeless feel to her expression, but the one on the right captures the giddy, silly little girl that probably has her mother wrapped around her finger.

The perfect expression is often just a slight adjustment away. The photo above has the girl looking at the viewer out of the sides of her eyes. By asking her to "bring your nosey a teeny bit closer to me," the slight turn of her head makes the eyes more centered, giving more power to her expression (right).

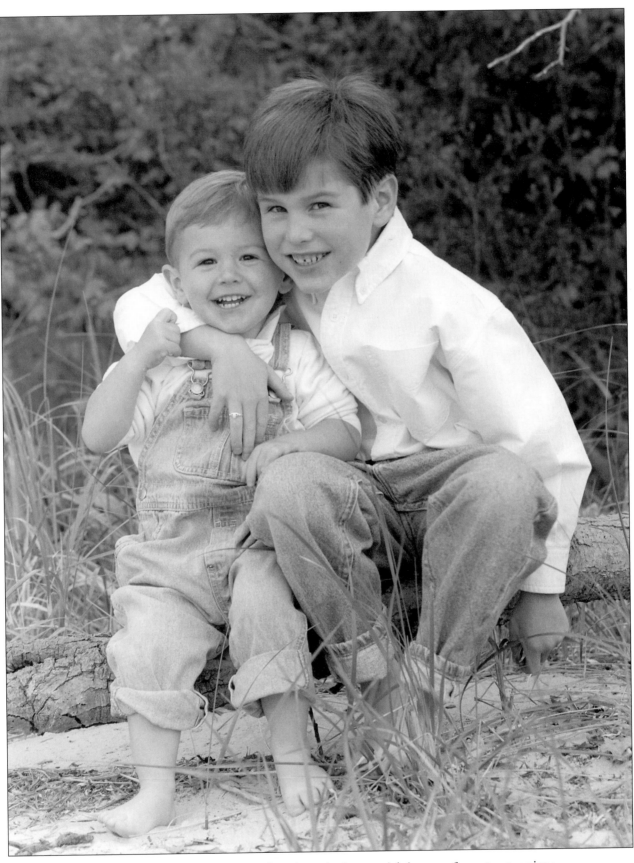

When you ask two brothers to hug, be focused and ready for a quick image of great expressions.

CHAPTER SIX

WINDOW LIGHT — WORKING IN THE STUDIO AND ON LOCATION

Basic Equipment Requirements

Photographing with window light should be the easiest type of both studio and on location portraiture because it requires no fancy equipment to create great images. You need your camera, a tripod, a cable release, a reflector, a light meter and a window.

Timing the Session

The ideal window is one on the north side of the home or studio because it will provide soft, even lighting virtually any time of day. When your window is on the "wrong" side, you adjust either when you photograph or how you use the light coming through the window.

> "The ideal window is one on the north side of the home or studio..."

The building our studio was located in for twelve years had a window that faced west, making it impossible to use as a main light

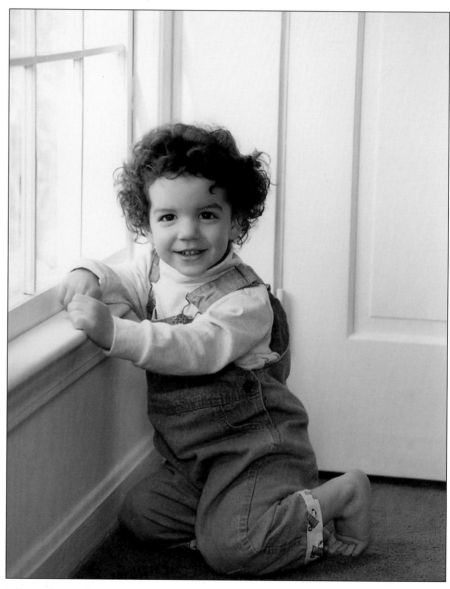

The only window I had access to at our office condo complex studio location faced west, so I scheduled my sessions for the morning hours before the sun had time to cross over the building and shine brightly into the camera room.

source during the afternoon hours. I scheduled sessions between 9 a.m. and noon when I wanted to use the window, usually for small children or for the classic mother-child portrait. Later then that, the sun streaks through the window, creating contrasty and harsh lighting on the subject.

The window must be positioned to take advantage of it as both the primary light source and an integral design element of the final photograph.

You may choose to include the window in the frame of the photograph, or move the subject so far away from it so the window doesn't show at all. You can position the subject so the window lights the front of the face, or so it lights only the side of the face.

Light Meter Reading Usage

Taking the light meter reading is the most critical aspect of photographing with window light because it can make or break the image. When your subject is looking out the window, even if the window is outside the viewing range of the image, take your light meter reading from the subject's nose with the meter pointing toward the window.

When the subject is looking at the camera, with only one side of the face illuminated by the window, take your exposure reading with the meter on the shadow side of the face and pointing toward the camera.

If you take the exposure reading from the window side, you will get a reading for the brightest part of the subject. That will cre-

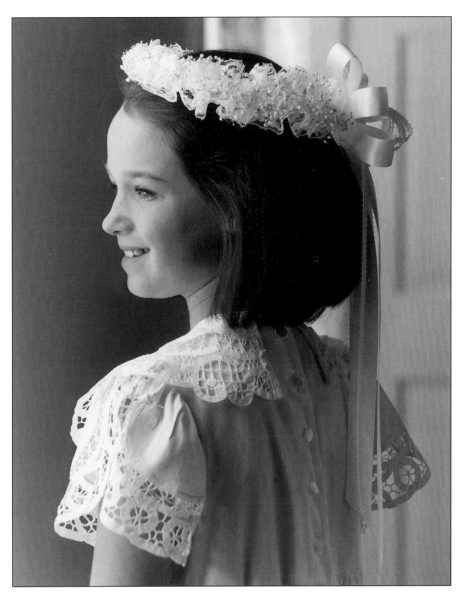

When the subject looks toward the window, take the exposure reading off the bridge of the nose with the light meter pointing out toward the window. Note that the window that is the source of the light is not included in the image. Another window, the one used as the main light source in the photo on the opposite page, is diffused in the background with a lace curtain.

ate a much too dark exposure reading on the shadow side of the face, making it look underexposed and dark.

It is better to have a correct shadow side reading and darken the highlight side by "burning in" the portrait during printing than to try to "dodge out" the light on the shadow side in an attempt to try to

unblock to darkness and show more detail.

You can improve your window lighting by adding a simple reflector to the side of the face opposite the window.

Position the reflector until you see it brighten the shadow side of the face. Then take your exposure reading from the reflector side

Window lighting enables you to create beauti-ful portraits with very soft lighting, regardless of whether or not a window is included in the final image. This tapestry creates an interest-ing background for a window light portrait. Since the soft lighting requires a wide open aperture (f5.6), the background falls nicely out of focus in the photo above. By having the sub-ject lean against the background (right), the background is almost as in focus as the subject.

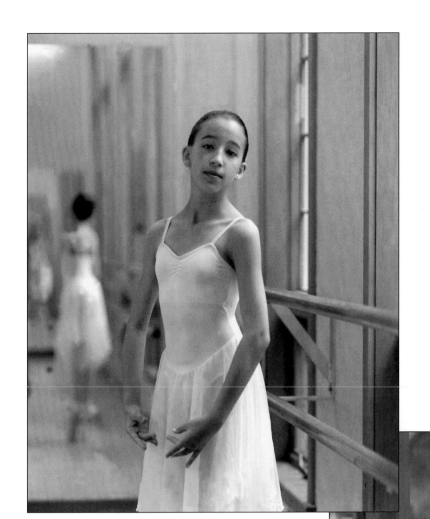

Above: This ballerina has been studying for many years at a local conservatory of dance which features a lovely bank of windows at one end of the room. Her experience in dance and her older years enabled her to hold poses for ⅛ second. The light wraps around her, adding depth to the background and soft light to the shadow side of her face.

Right: The window is both the main light source and the main background. The portrait shows the teenage girl with her two best friends, the telephone and the girlfriend she is chatting with. The portrait was taken a few weeks before the family sold the home and moved across the country. This portrait captures forever the memories of both the teenager and the home.

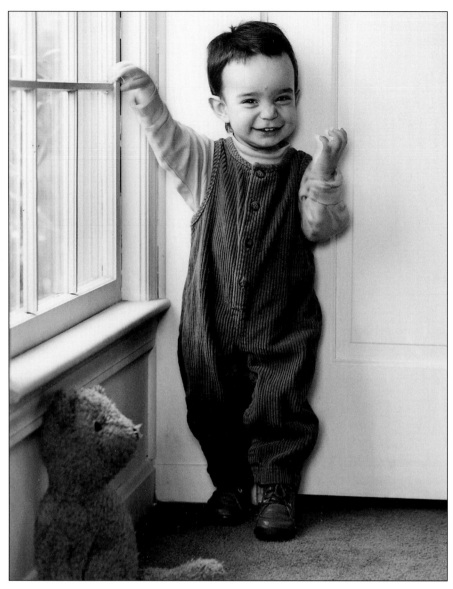

Motion shows in both hands because the toddler moved quicker than my shutter. It is difficult to create a portrait of any toddler standing because they always want to take off running. I placed his hand on the widow and snapped the picture before he took off. Once this trick no longer holds his attention, I bring in a chair or have the child kneel like in the photo on page 56.

and excitement, but motion in the face just flat looks out of focus.

Using Windows On Location

Using the natural light of a window is the ideal way to photograph on location because you do not need to bring anything but your camera, tripod and light meter.

"Using the natural light of a window is the ideal way to photograph on location..."

To create soft light on the shadow side of the subject without relying upon a reflector, I use a slower shutter speed than I would if I were back at the studio.

Instead of setting the camera at $1/30$ second at $f11$, I use a technique called "dragging the shutter" and set the camera to $1/15$ of a second at $f8$. This allows more time for the light to wrap around the subject, enabling more detail to show up on the shadow side of the face and in the background of the image.

of the subject. A small silver reflector on a light stand will enable you to add one-half to one full stop of light to the shadow side of the face. The portrait will still look natural, as if you did not use anything besides the widow to create the soft lighting.

Even during the brightest days, you will be using fairly slow shutter speeds to create your window light portraits. I use Kodak Tri-X Professional rated at 320 ASA, and my exposures range from $1/15$ to $1/60$ second at $f5.6$ or $f8$. I avoid $1/15$ second because it is too easy for little ones to move quicker, causing an out of focus look to the image. Motion in the hands makes the image have a sense of energy

CHAPTER SEVEN
STUDIO LIGHTING OFFERS QUALITY CONTROL

The primary benefit to using studio lighting for your black and white portraits of children is to guarantee you have one hundred percent control over the quality of the lighting.

You can create literally any kind of lighting, any time of day and with any type of background. All you need is a basic understanding of how to plug in a few lights and how to use your light meter.

Equipment List

Basic lighting equipment includes a main light, complete with a light stand and something to bounce or reflect the light into to create a softer output.

You can have a smaller version as a secondary light, or you can use a reflector on a light stand for your fill light.

You may choose to add an overhead light (also called a separation light or a hair light) and/or a background light.

Because I prefer to fiddle with the subjects, and not with my lighting, I limit myself to a main light and a fill light.

All of the portraits shown in this chapter were taken with a White Lightening main light pointed through a large softbox. The secondary or fill light is a large silver reflector on a light stand. I did not use a background light or a hair light on any of the images.

Practice Makes Perfect

When you understand exactly what your equipment can and cannot do, you can create a variety of lighting styles with a limited amount of lights.

> "…you can create a variety of lighting styles with a limited amount of lights."

Practice definitely makes perfect. You should be familiar with what happens when you move a light closer to the subject, or farther away. You should also know how much fill light you can add to an image by simply using a slower shutter speed on your camera.

When you know the strengths and weaknesses of your equipment, you can then help your client choose the studio portrait look that best suits her objectives.

The following gallery of images show the different lighting styles from moving around two basic lights.

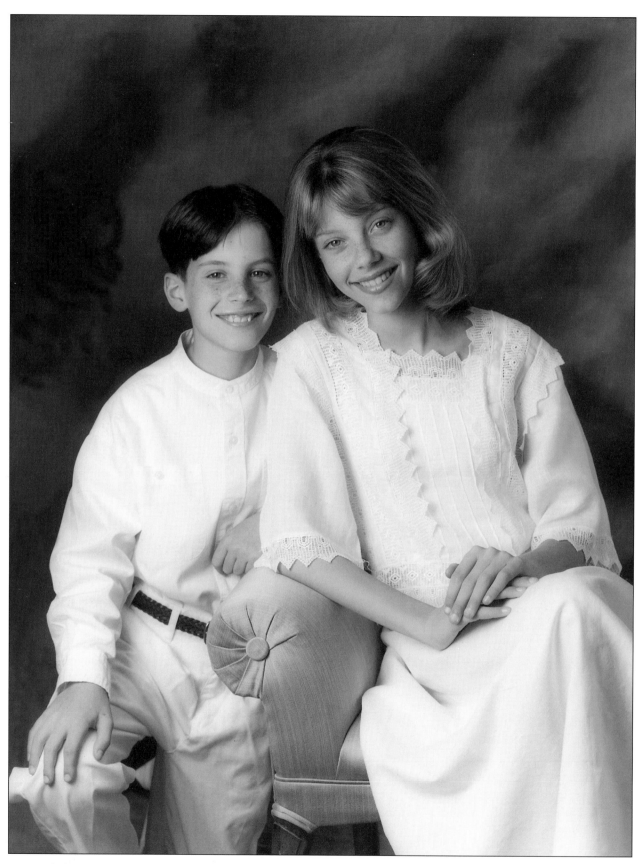

Formal clothing makes a formal studio portrait the ideal choice for this brother and sister. A window on the right side of the image adds a little bit of fill light, putting just enough light on the painted background to give the portrait depth.

Above: Classic low key lighting calls for a dark background, a dark prop and dark clothing. This infant "breaks the rules" by wearing a middle tone, but the dress blends beautifully with the tone of the velvet chair.

Right: Classic high key lighting calls for a light background with a light prop with white clothing. The seersucker dress is not the white used by many photographers for classic high key, but it adds interest to the image and helps to tie in the tones from the baby's teddy bear.

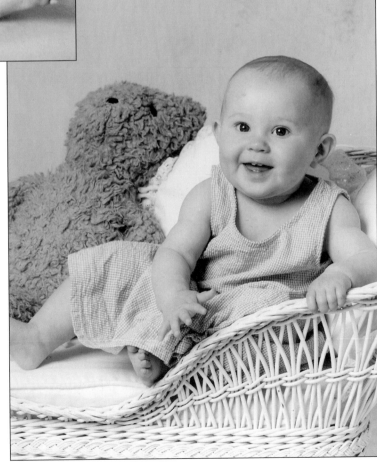

Moving the main light in close to the subject helps to evenly illuminate both sides of the face. A reflector gently fills in the shadow side of this low key portrait.

By moving the light back away from the subject slightly, you can create a more dramatic lighting effect. Just make sure you make a deliberate choice where to position the light, and then understand the consequences of the placement.

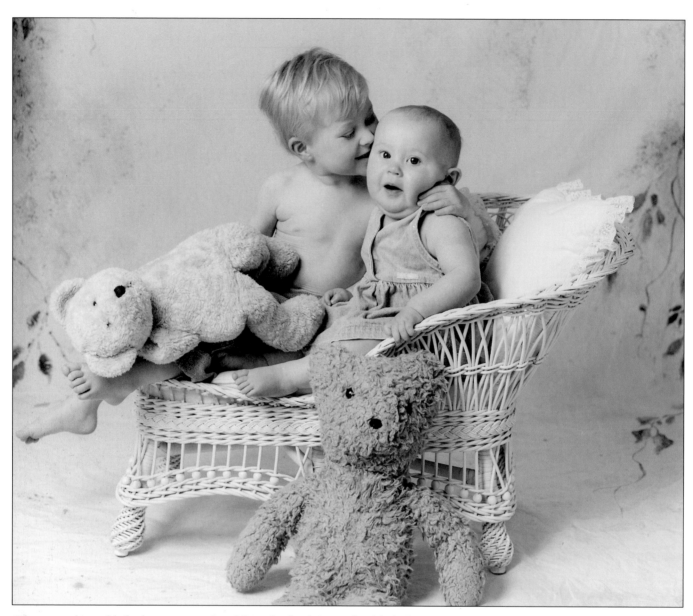

Photographers think that you need to blast the background with light to get a high key effect, but there is no background light on this muslin and it still looks white. The trick is to use a slower shutter speed and take advantage of room light. There is a large window to the left of the image, which provides ample light to fill in the shadows on the right sides of the subjects and to create the white on the background.

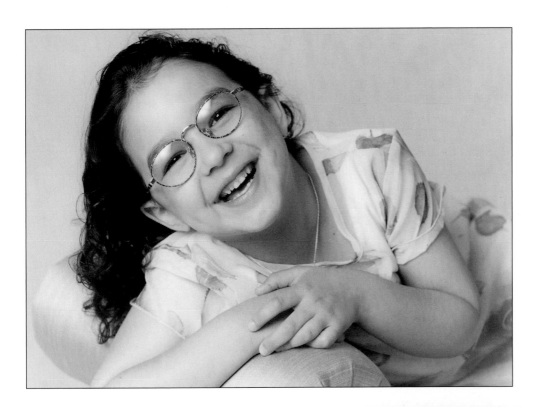

It is much more difficult to photograph a subject wearing glasses in the studio than it is outdoors. I always ask the mother to go to the optometrist and ask to borrow a pair of blank frames that are similar to what the child wears. More often than not, you have to photograph with the glass in the glasses. When the child lowers her chin (right), there is no glass glare. When you capture a more candid moment with the child laughing(above), you cannot avoid glass glare. Sometimes the glare adds interest to the image, and other times it is distracting. I use a combination of spotting dyes and graphite pencil to remove the glass glare. Unfortunately, it must be individually done on each portrait.

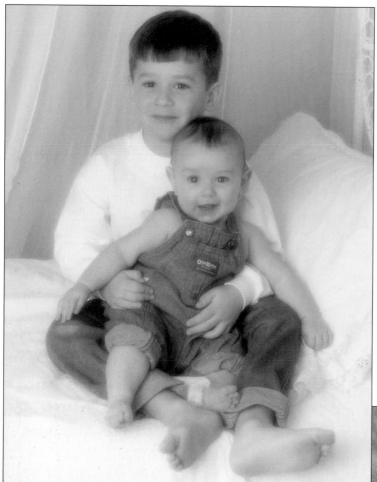

Above: By moving the subjects close to the background, the main light provides enough illumination on the background to keep its correct white, high key effect. The soft focus effect was created by dropping a Nikon One soft focus filter into a Lyndal shade (remove the outer ring and attach a piece of masking tape to the edge of the filter so you can easily and quickly move it in and out of the shade).

Right: Muslin drapes are a popular backdrop for studio portraits. You can drape them to add texture and depth to the setting, as in this photo. Or you can hang them so they resemble a painted background (see bottom photo on page 63 and bottom photo on page 69).

The shutter speed you use can dramatically change how your background looks. The faster the shutter speed, the less natural room light you are allowing to fall onto the background. The lower the shutter speed, the more light will wrap around the subject and onto the background. Both photographs were taken on the same muslin backdrop. Both were taken with the main light and a reflector. The photo on the right was taken at $\frac{1}{250}$ second to stop the motion of this very fast little girl, but the photo above was taken at $\frac{1}{30}$ second. The boy's portrait has a low key effect with a dark background and dark clothing. The girl's portrait is a medium key on both the subject and the background.

CHAPTER EIGHT
AVAILABLE LIGHT PORTRAITS ON LOCATION

Looking for Ideal Lighting

When you photograph on location using only available light, you must learn how to "see" light. Instead of creating the same lighting style you use in the studio, you are stuck with using whatever Mother Nature provides. The trick is to know what you are looking for and then use it to your best advantage.

Variables in Outdoor Photography with Natural Light

The major light variables include time of day, direction of the light to the subjects and strength of the light depending upon whether it is diffused through clouds or trees, or whether it is a bright light beaming straight from the sun to the subject. The weather is the wildcard variable because it alters the predictable light you might expect for a given time of day by bringing in haze, fog or clouds. Every location offers several different types of light. You just need to know what you are looking for.

This image is still technically back lit because the main light source, the sun, has set directly behind the subjects. The afterglow illuminates the sky, creating an even lighting pattern across the faces. The only hint of the low light level is the motion in the boy's hand. The exposure reading was taken from the faces with the meter pointed toward the camera.

Backlit images use the brightest light source, usually the sun, behind the subjects. The correct light meter reading is taken from the shadow side of their faces, with the back light creating a bright rim of light on the hair or the sides of the faces. Whether the subjects are white or black, the light meter techniques and camera exposure remain the same.

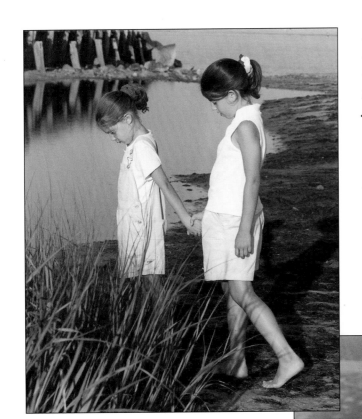

Broad light is defined as the main light source hitting the subjects straight into the faces. When it is a bright day, the challenge is to keep the subjects from squinting. In the photo on the left, you can see the long shadow behind the girls that is created by the strong broad light. It was too bright to look on camera without squinting, so it was an ideal time to create an illustrative style image. It is about thirty minutes later on the photo below, and the sun has softened enough so the girls' eyes are not bothered by the bright light. Another half hour later, the sun is slipping behind the horizon in the lower left photo. The sun is still technically "broad light," but it is greatly diffused by the lateness of the hour and the horizon.

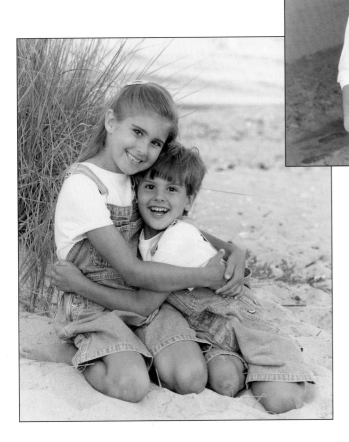

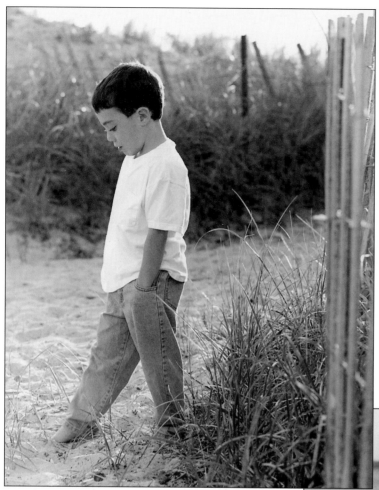

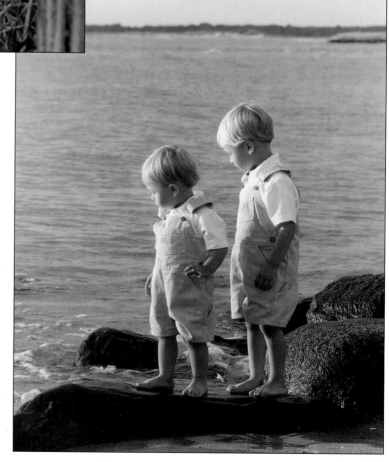

Above: As the sunlight softens, the lighting ratio also softens. The camera was set for the exposure reading from the boy's cheek, and the back light adds sparkle to the background and a rim light to his hair.

Right: To use the back lighting in almost a reverse fashion, turn the heads toward the light. Then take the exposure reading off of the bridge of the noses.

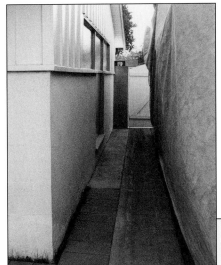

Left: Scene A. The walkway to the back yard goes between the garage and a covered motor home. The area is in heavy shade. Kodak 3200 film.

Below: I began the session in the shade beside the garage to allow time for the light in the front of the house to soften. A closeup adds variety. Kodak 3200 film.

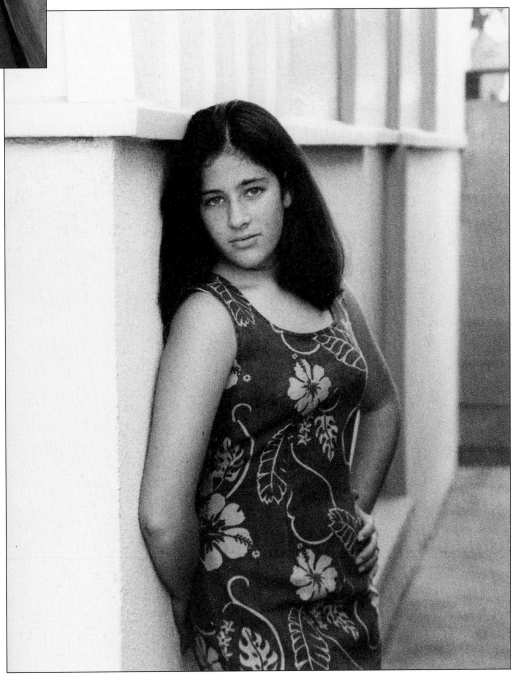

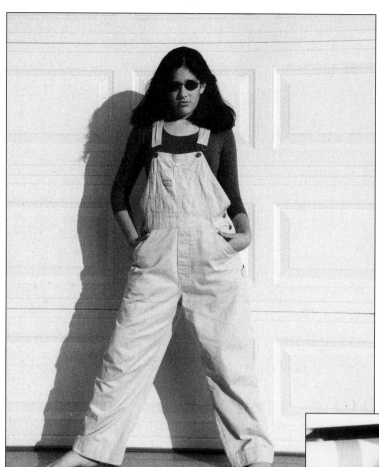

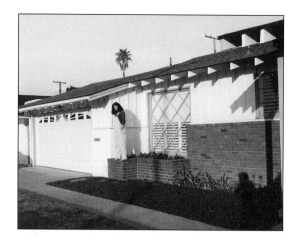

Above: Scene B. This front yard is brightly lit by the setting sun. No clouds or trees offer any diffusion to soften the harsh light. Kodak 3200 film.

Above: I used the bright light out front to create a spotlight effect against the garage. Kodak 3200 film.

Right: A closeup image with the house as a backdrop incorporates the bright light and a jazzy teenage look. Kodak 3200 film.

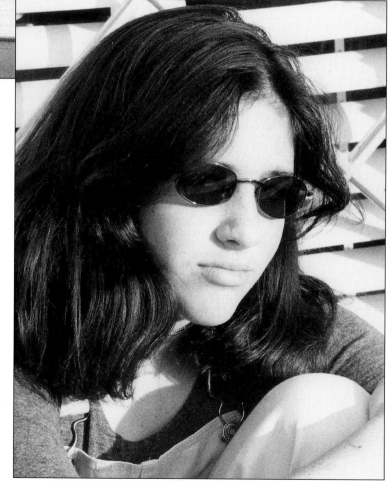

Eyeing up a Location

I always arrive early to a location, even when I have photographed there hundreds of times, to ensure my camera is set up and ready before the client arrives. I also want to allow time to walk the area, looking for the light patterns and testing the wind direction for the day.

I also like to get a crowd count and see how many other people are at the location. I walk full circle around a given location and visualize how I can get the most variety and the most pleasing light patterns from the setting.

You can find pleasing light and interesting backgrounds in the most unexpected places.

Controlling Light by Controlling the Time of the Session

The best way to control light is to control the time of day you photograph. The light is the softest at sunrise and sunset. Summer sunrise on the Cape Cod is 5 a.m., and there is nothing worse than setting the alarm to get up and ready for an early morning session only to discover that you are fogged in. I prefer to work with sunset light because I like to watch the light get better and better as the sun gradually sets.

Sunrise seems to happen quickly, with the sun shooting upwards at an alarming rate. Instead of the light getting better and better, it gets worse and worse!

The sun rising or setting creates an obvious light pattern and light quality. There are also plenty of light patterns that are not so easy to see. When you are looking

These two teenagers were particularly sensitive to light in their eyes. We started the session by working in bright haze, but the light was ultimately too bright for their eyes. We moved under a dense overhang of trees into heavy shade. The exposure was ¹/₁₅ second at f5.6, and the teenagers and background have all the detail you would find in bright sunlight.

for light beyond the obvious sunrise or sunset, remember that the film can record light on a greater spectrum than your eyes actually see.

I learned this all important concept when I took a photography class with California photographer, David Peters. He included a segment on "working in less than perfect light," and he showed how

to find light in locations that I never would have looked.

The most important point to remember is that every location has both highlights and shadows. As long as you take a correct light meter reading, match it to your camera and get your clients to sit quietly for the long exposures, you will have images with a wide range of grey tones.

When you are working with slow exposures in heavy shade, the film will record highlights that your eye doesn't notice, like the soft hair light on this high school senior.

When you can't find a large area of shade, position your subject well within whatever shade you do find. Ideally the sun should be behind trees and slightly behind the subject so that any overflow lighting will hit the hair and not look blotchy on the face. Since your exposure reading will be for the shadow side of the face, sunlight will show up in the background as strong highlights.

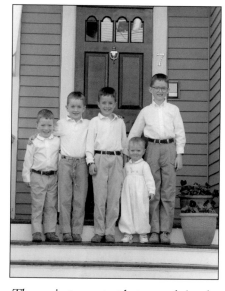

The easiest way to photograph in the middle of the day is to find a chunk of shade. The front porch was in full shade, so I started my photography session here with an exposure of f8.5 at ¹⁄₃₀ second.

Not everyone is available to be photographed at the end of the day when the light is soft, and it is very challenging to find the right light when you photograph in the middle of the day. The rule that remains constant is that you absolutely must take correct light meter readings off of the faces of your subjects.

Working with Inclement Weather

The single most unpredictable and uncontrollable factor when photographing on location is working with the weather. When I give each client the scheduled time for the portrait session, I always point out that it could go up or back depending upon the weather

for the day. My initial time frame is a little bit earlier than I actually think I will photograph because it

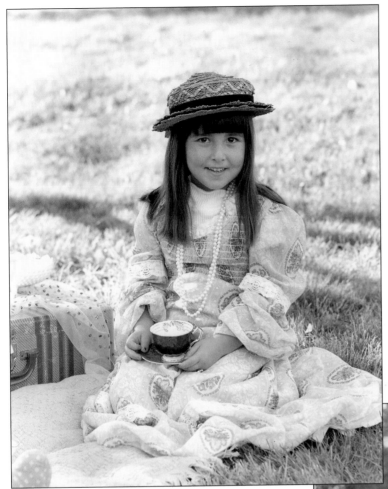

With studio lighting, you alter the background by dragging the shutter to allow more light to fill in the shadows, but you change an on location background by changing the angle of your camera to the light. Both of these photographs were taken at the same tea party, under the same tree and on the same blanket. The faces of both subjects are in full shade, and the light meter reading from the faces enables you to create an image with correct skin tones. The backgrounds differ because there is no shade in the background of the photo above, but the one on the right is in partial shade. The lighter background matches the girl because of her lighter dress, and the darker background is more appropriate for the boy because of his darker suit.

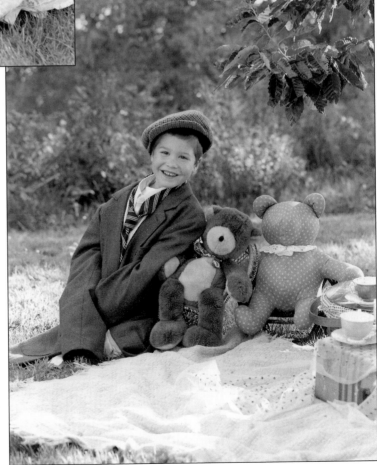

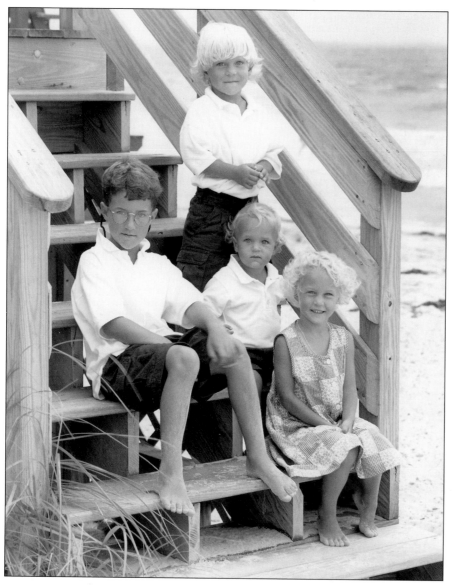

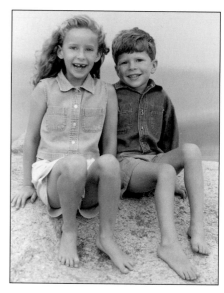

It is Murphy's Law that when you photograph a photographer's family, the worst weather sets in. It literally started sprinkling as soon as the family arrived to the beach after a three-hour drive from off cape. The kids wanted to run up and down the beach, but instead we had them sitting still for the ⅛ second exposures. Other than the hazy horizon line from the low depth of field, you would never know it was a cold and windy summer day.

When a hurricane was racing up the East Coast, I called all my clients to see who wanted to get to the beach ahead of the wind and rain. The steps worked as a great prop to keep the kids from wiggling, and it helped to cut back some of the pre-hurricane winds.

is not uncommon for a bank of clouds to move in at the end of the day, making the quality of light fall off sooner.

It is easier to ask clients to come a little bit later in the day than it is to ask them to quit work early and scramble to the Cape for a portrait session.

I ask my clients to call and confirm the exact time of their ses-sion by early afternoon the day of the session.

Once the noon weather fore-cast gives the revised weather pre-dictions for the day, we make a game plan.

The ones who are able to scramble and beat bad weather are the sessions I am able to salvage when the weather turns to fog or rain or haze or hurricane. Those who cannot juggle and get here sooner, I have no choice but to reschedule.

Contingency plans vary from one part of the country to another. You should determine a plan to accommodate the weather patterns for your area during the seasons of the year you photograph outdoors.

For example, a photographer in New Zealand gives clients a loose session date for a particular week.

Then, the beginning of each week, once the weather forecast is more or less determined, the pho-tographer gives a definite date and time for her clients that week.

Sometimes scrambling to beat bad weather turns out to be the wrong idea because the bad weather never arrives and the sunshine comes blazing out. It was a "guaranteed" downpour day when we scrambled to do this sunset session mid morning. The clouds moved away, leaving very bright haze. Correct exposure becomes critical to avoid what photographers call "raccoon eyes". The older girl was photographed in thick shade with the bright sky to her back (above). The whites in her eyes show up beautifully. The bright haze from the sky over head is illuminating her little sister, causing her eyes to become dark sockets, or "raccoon eyes" (right). The problem is easily corrected by using a retouching pencil to add the whites back into eyes. (You could also use a reflector or a low wattage flash to fill in the shadow area of the eyes when you take the photograph. I prefer to control it with the artwork after.)

Chapter Nine

Tips for Photographing Tots to Teens

Defining the Ideal Age for a Child's Portrait

When mothers call to ask what the perfect age is to photograph a child, I always tell them that right now is the best time. The old saying, "Never put off until tomorrow what you can do today" is never more accurate than when it comes to photographing children.

Whether the caller has a newborn or a teenager, the child will never be the same tomorrow as he or she is today.

> "...the child will never be the same tomorrow as he or she is today."

Not only do kids change quickly, but parents get busy and life has a way of bolting past. I have never heard parents complain that they photographed their children too much, but I always hear them lament that they did not photograph them often enough.

Mothers are more inclined to photograph their children more frequently from birth until first grade because there are so many obvious changes.

These same children do a lot of growing and changing during the grade school and teenage years, but families are usually so caught up in the chaos of raising a family that these years slip by with very few portraits. Then, one day the mother looks at her child and says, "Wow! How did little junior get to be so big?" Then they pick up the telephone and schedule a portrait session.

I am not picky about the ages of the children I photograph because I am always honored when a mother places the responsibility upon my shoulders to freeze frame a slice of her child's life. So, when the mother asks if now is a good time to photograph her children, my answer is always, "YES!"

My overall approach to working with children of all ages is to treat them with respect. I always introduce myself to each one of the children. That means I often get on my hands and knees to become eye level with a two-year-old. Then I extend my right hand, look them right in the eye, and tell them my name is "Mrs. B."

Mothers will often introduce me to their children by my first name, but I don't want to be on that friendly a basis with the children. "Mrs. Boursier" sounds too formal, so I shorten it just enough to make it easy for the kids to say while also giving me the respect that comes with the "Mrs."

After all, from pre-school age up, children address their teachers with some sort of formal prefix. The prefix subtly tells children I, like a teacher, am the boss! The one on one handshake and greeting shows them I care, and the official introduction sets the mood for me to be in charge during the photography session.

The Difference Between Boys and Girls

When it comes to photographing children, all ages (not to mention both sexes) are definitely not created equal. Different ages respond differently to what you say and do to capture their personality on film.

A trick that works to get the cooperation of a two-year-old boy is not the same move that will work with the same age girl. And, although it is a sexist comment to make in our politically correct world, boys and girls of the same age usually respond differently.

I believe that a major factor in how differently boys respond compared to how girls respond is that, in spite of our modern world of equal rights, parents continue to treat an infant girl differently than they treat an infant boy. We snuggle and cuddle our daughters and we bounce and jostle our sons.

No matter what age child I photograph, the cuddle verses the jostle difference shows up.

Generally, that means I speak a little softer and a little more gently to girls, and I talk a little louder and a little goofier to boys. I also accept that most little girls are proud of the pretty clothes their mothers dressed them in for the portrait. I accept that most little boys could care less what they are wearing. All they want to do is get the session over with so they can play.

I tried to fight this difference during my early years in photography, not to mention my early years in parenting, but going with the flow creates much more natural and believable portraits. Of course, there are exceptions to both sides, but generally it makes it a lot easier on everyone to let boys be boys and girls be girls.

Baby Portraits

The male/female difference shows up the least in babies, probably because they have had the least amount of conditioning by their parents.

I prefer to photograph babies when they are at least five or six months old. Their backs are strong enough so they can sit up with very little assistance. Also, their perky smiles are adorable and easily

Baby portraits have a lot more meaning when you ask the mother to bring some special items from the nursery. This image was photographed with a Nikon One soft focus filter and Kodak Verichrome Pan film, rated at 100 ASA.

The wicker settee is a great help to keep both a toddler sitting still and an infant propped up. The big sister helps keep the baby in place.

coaxed. The choices for "propping" include lying babies on their stomachs or on their backs or using pillows to help them sit in a chair. For newborns, you need a lot of pillows and a low camera angle. To help coax smiles, use a small plastic toy that squeaks. It will only work the first few times you use it, so the less often you squeak it, the better.

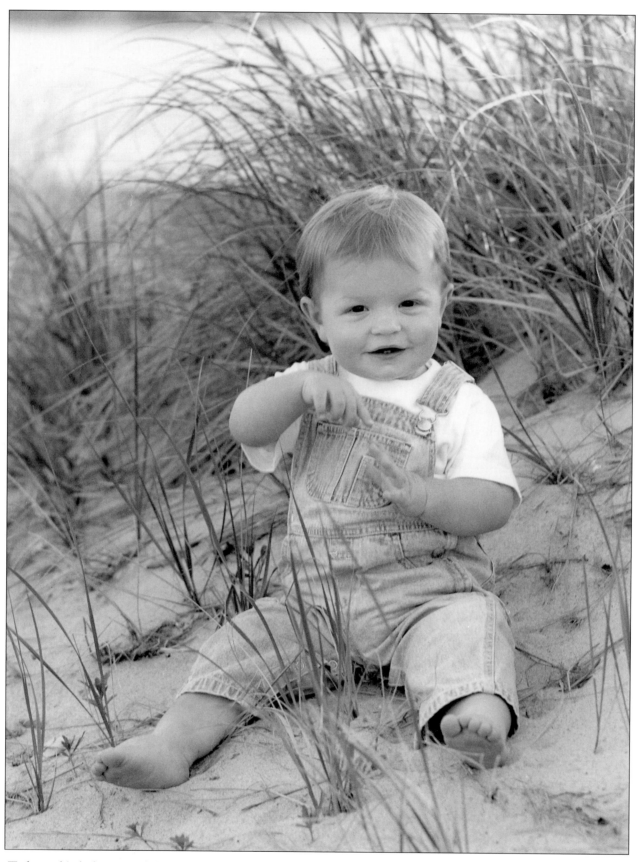

To keep this baby from sliding down the dune, I scooped out some sand under his bottom. The dune looks the same, and the baby stays put. His mother is singing about the spider climbing up the water spout. Most babies twelve months old and up know the song, and singing it creates the hand motions that show off his fingers.

I carry one or two wicker props in the trunk of my car for the duration of my outdoor shooting season because I never know when I will need a prop for several small children or for one infant.

It helps to have several pillows to tuck around and behind the babies when you photograph them solo so they can comfortably (and safely) sit up. Also, I always place the baby's hand on the wicker because, for a brief moment, the hand helps the baby to feel more stable. Playing "peek-a-boo" is a great game for a baby.

Toddlers

Babies cross the magic line into toddler the moment their feet hit the floor. Those tentative first steps quickly turn into running. It never ceases to amaze me just how quickly a toddler can scoot across the room or down the beach and into the water.

You must work super fast when photographing toddlers. They have the shortest attention span of all the ages because they are just too busy to sit or stand still. The boy/girl difference is already noticeable as I have a much better chance getting a girl to sit still than I do a boy. With either sex, you must make the photography session a fun game so they will enjoy "playing."

> "You must work super fast when photographing toddlers."

It is risky to use any kind of squeaker or toy to get the toddler's attention, because toddlers usually

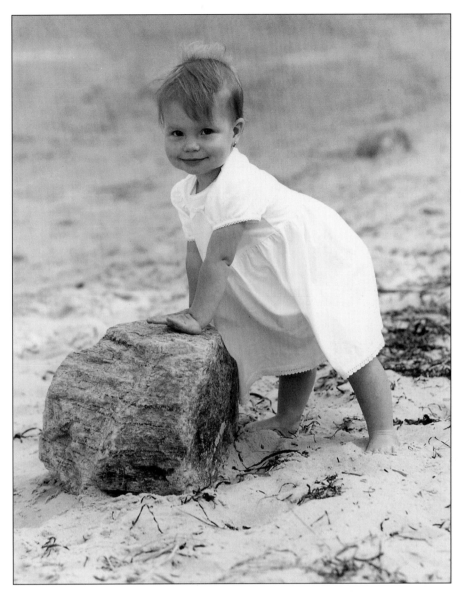

Using a "still" camera to photograph the very mobile toddler is very challenging. I look for a prop that exists within the environment. Then I try to get the toddler interested enough to stand on, sit on or climb on the prop. I often have the mother race in with the child, position the hands touching the given prop (like the rock here) and then race off. The toddler thinks it is a funny game. I have the chance to take one image before the toddler runs after mom. Then, we repeat the process once or twice until the child gets bored and we move on to a new prop.

stretch their chubby little hands in your direction and grunt a nonverbal demand that you turn over the toy to them. When I do use a toy, I bring it in and out of the child's visual range very quickly. I have a dozen stuffed animal puppets including favorite Sesame Street® and Disney® characters. I keep them inside a chest and bring out one at a time. I might use it for one or two clicks of the shutter. Then, I race off to put it away and ask the child to guess which friend

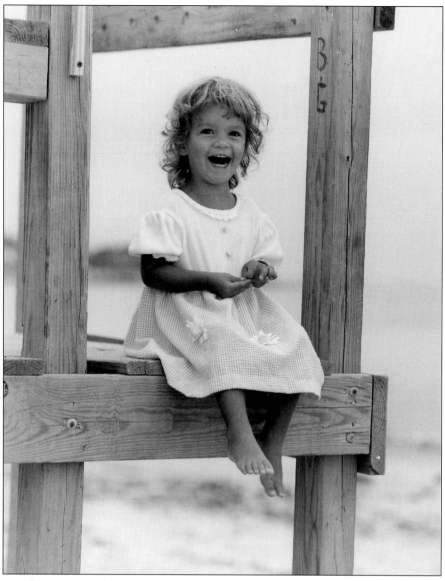

This wild one had a grand time running all over the beach. The only way we could get her to sit still was to put her up on the lifeguard chair so she couldn't run off. When I do lift a child up high, I always make sure a parent is within range to do a quick catch. Toddlers have no concept of height, and they have virtually no fear. I make sure the parent is ready to dive in for a quick save in case the toddler opts to jump off!

I am going to bring out next. Switching toys quickly distracts the child, and the moment I slow the process now, the child gruntingly demands the puppet.

You can use picture books to keep pre-school children sitting still long enough for you to take some images. If the child is clinging to mom, the book helps to dis-

tract and relax the child. Often, the mother can gradually inch her way out of the camera's frame while still reading the story and keeping the child's interest.

Tiny stickers work to keep tots interested. I often put one on the floor and ask the child to "hide that sticker with your foot." It makes a game of getting the child

to stand still long enough for a quick click.

I also put stickers on the window when I am trying to do a window light portrait and the child keeps running away from the window. Kids like to try and peel the stickers back off of the window, allowing me a few split seconds to take a picture.

Elementary-Aged Children

One of the most popular times to photograph a pre-school to first grader is when a front tooth is loose and mom wants a portrait before the "goofy" phase of missing teeth and "big teeth" sets in.

Personally, I think all the phases, from losing baby teeth to getting teenage braces, are priceless. Each one represents a passage of the child's life.

Four and five year old children, both boys and girls have one very predictable habit. They have just come to realize that they control their smiles. They like to show you they are in control of the portrait session by choosing when to smile and when not to.

"…I think all the phases, from losing baby teeth to getting teenage braces, are priceless."

Of course, this drives the parents crazy! I remind parents to bite their tongues and let me do my thing.

I pull out all the stops to be extra zany so the children forget to be in control of their smiles. Instead, they just have fun!

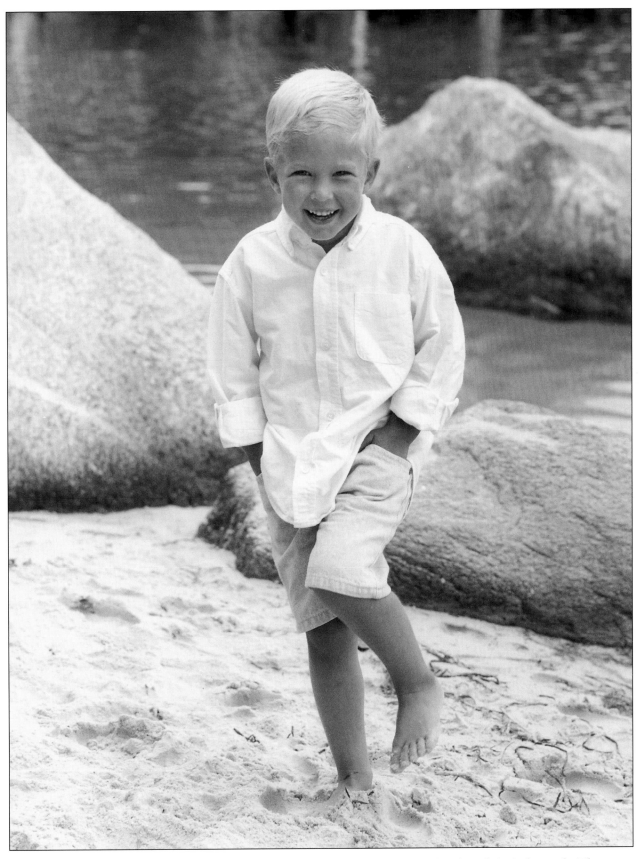

It is common for me to get requests to photograph children right before they lose their baby teeth. The sweet look will never be quite the same once the "big teeth" start growing in.

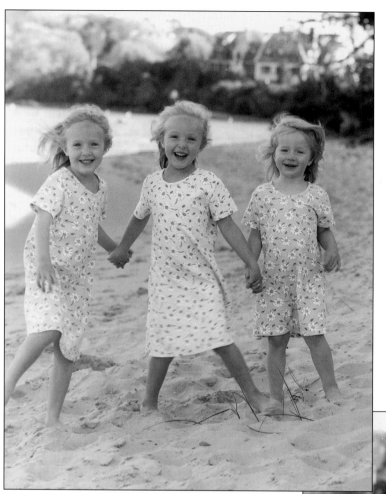

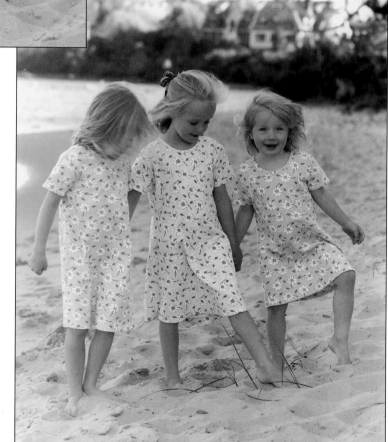

Where boys are often rowdy, little girls enjoy being silly. They want to sing and dance and spin. Having the three sisters hold hands helps to keep them still, but it only helps a little bit. I keep their attention fixed on me by singing silly songs or asking them to tell me a knock-knock joke. To get them to settle down, I will tell them to do something unexpected like "look at your sister's toes." Nobody tells them to do something as basic as that, so they stop being silly and look at their sister's toes!

It is difficult to photograph children standing because they naturally want to move around. To help them stay put, I will have them reach up and hang onto the fence or perhaps lean against it. If boys are being fidgety with their hands, I will ask them to put one or both in the pockets of their shorts or slacks.

Teenagers and Young Adults

Teenagers require special handling. Most teenagers are very self conscious about what they look like and about what they do in public with their family. (Being cool is everything, and being with your parents is rarely cool.) Teenagers also have very specific tastes in clothing, and what mom told them to wear to a portrait session is not likely on their list. I try to get the teenagers on my side by pointing out how this portrait session is scoring big points with mom. If that doesn't work, I just let them know I have all the time and film in the world and that we can stay here all day if that is what it takes to get the job done right.

Teenage girls are more likely to cooperate immediately, but the boys often put up a stink. It is as if the girls know mom is going to win eventually so they may as well give in gracefully, but the boys are still thinking they can dig their heels in and get their own way.

When it comes to getting the boys to take off their ball caps, take off their ugly sneakers to go barefoot on the beach and getting them to turn their t-shirts around so the jumbo logo is on the back of the shirt with the solid part in front, I always win. I start by asking politely. Then I try to get them to see the benefit of pleasing mom. Next I move to the badger phase where I tease them.

My last recourse is to threaten to make the portrait session take as long as possible by doing more and more poses and using more and more film. If being nice doesn't work, the threat to extend the session always does!

This young lady would have been happier wearing jeans and a t-shirt, but she graciously agreed to her mother's request that she wear a more formal dress. Because she has such beautiful hair, I pulled it around to the front to show it off.

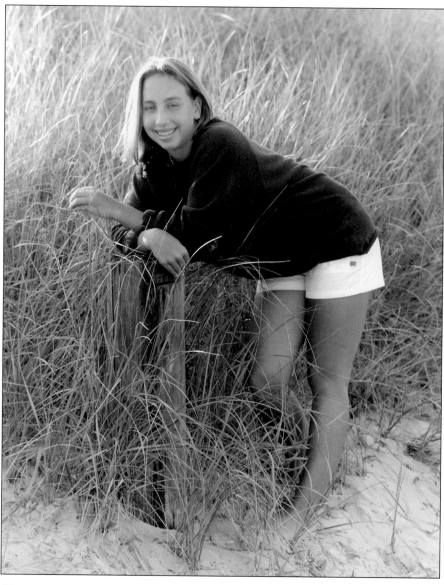

Braces are synonymous with being a teenager. Many are self conscious about the "tin grin" look, so I always point out that the braces will barely be noticed since I am using black and white film. The kids relax, and I am able to capture their natural smiles.

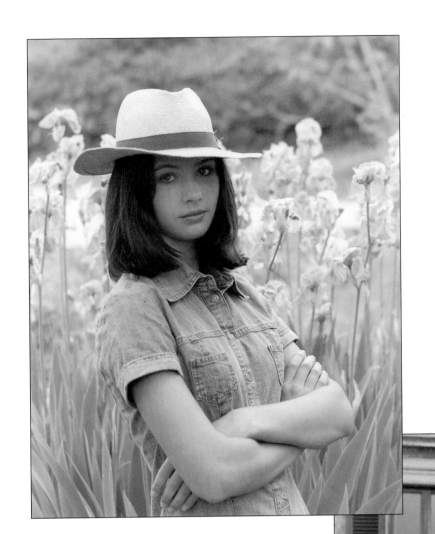

Compromise and negotiation are the norm when working with teenage girls and their mothers. That usually means photographing both for the mother, in this case the hat, and for the teenager. The end result is two totally different looks and two totally happy people. These portraits were created during a photo workshop in Italy.

Photographing high school seniors is a whole separate category because you need to meet a lot of expectations within one session. The poses should include full length portraits that show the environment and the entire outfit plus close-up poses (above) that can be used for the yearbook. The seniors will choose wallets (right) that they give to their friends as well as an official graduation pose they can send to grandparents. The selection should enable seniors and parents to have plenty of choices.

Chapter Ten
Mixing and Matching — Boys and Girls in Groups

Photographing groups of children offers an entirely new set of challenges. Instead of dealing with the issues of age and gender on an individual basis, now you have every combination imaginable.

> "...the ultimate objective is to capture the split second when everyone is getting along."

Whether you are photographing siblings or cousins, the ultimate objective is to capture the split second when everyone is getting along.

The casually perfect look must now extend to all of the brothers and sisters or all of the many cousins at one time.

Working with Different Ages and Different Sexes within One Group

The most interesting part of photographing a mixed bag of children is the very variety that presents itself.

One child might love to be photographed and another might

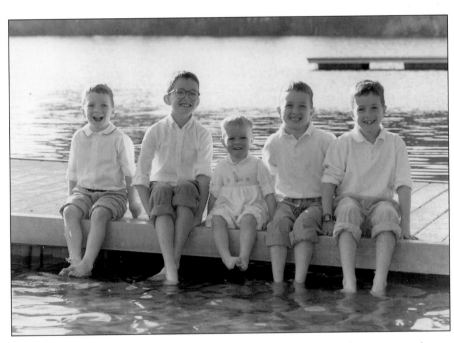

My zany antics tend to get children wired, and, by the end of a portrait session, they are just ready to run wild. I used the dock as a prop to get these five brothers to sit still for one last set of images.

hate it. One could be a bubbly, outgoing child where another one is afraid of strangers and very introverted. Just like when you are photographing individuals, your objective should be to photograph the real personality of the children.

Sometimes that means one child in the picture smiles, and one does not. The challenge is to encourage mothers to accept their children as they are and to help

parents not judge their kids too harshly.

Early in my photography career I had a mother who did nothing but criticize her children. She followed them around the beach with a hairbrush and a can of hair spray, and she constantly fussed at them for how they did or didn't smile, about how they were sitting or standing and about how their clothing was getting mussed.

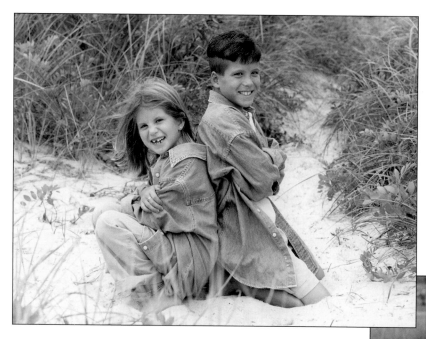

When I am photographing brothers and sisters together, I try to show the relationship the children have with each other. The children in the photo above have a playful relationship. You can feel the love and sense the nurturing of the older sister in the photo on the right, and the portrait of the siblings on the bottom shows three distinct personalities within the group.

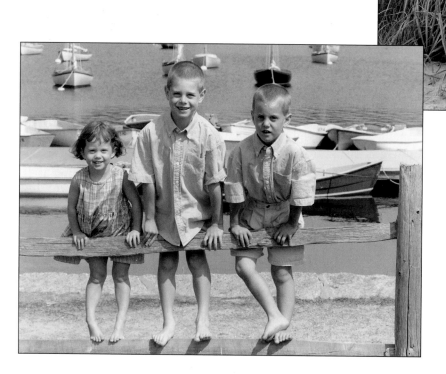

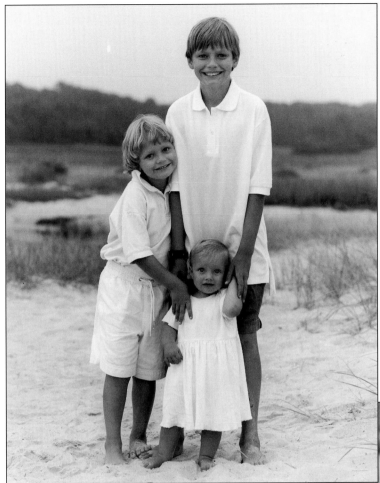

When I mix "big kids" with "little kids," I always take one portrait that shows the height differences and another that keeps all the faces close together. I think the full length standing pose is interesting because it shows scale, but I also like the closeup because it takes the emphasis off of who is the biggest and onto the adorable expressions of all three.

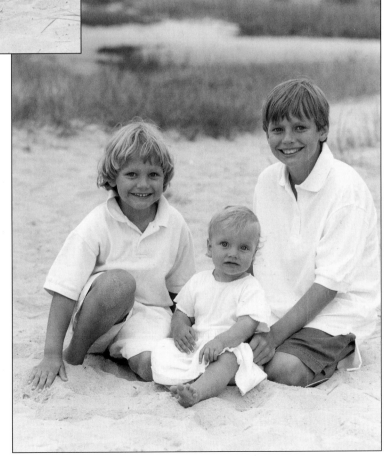

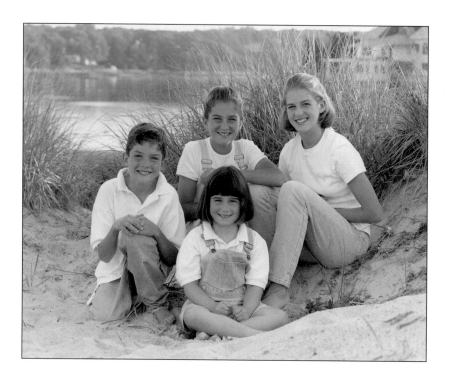

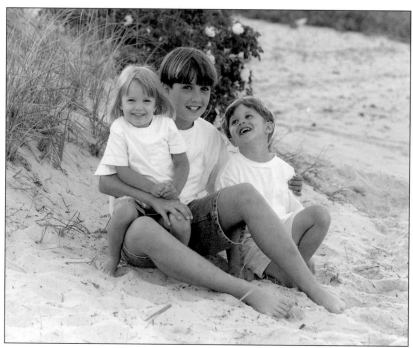

Top: Every session I photograph with siblings includes one image where the oldest is positioned taller or higher in the composition with each younger one posed a little lower. I like the oldest to look the oldest, and the youngest to look the youngest.

Bottom: I want to show pure joy when I photograph a blended family (i.e. stepchildren). The kids often don't live together all of the time, so they either don't know each other very well or they look at each other much like cousins. Meanwhile, the parents want all of their children to love one another as much as the parents love each other. I had an easy job with these three because the younger two adore their big brother.

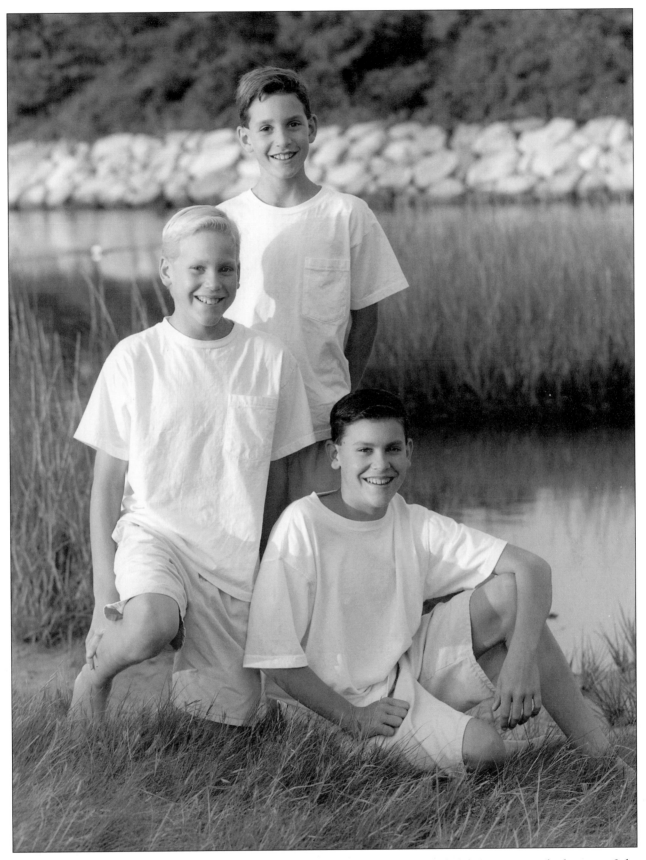

I often photograph siblings with the oldest at the top of the composition and the youngest at the bottom of the image. I switched roles here and gave the youngest a chance to be the tallest.

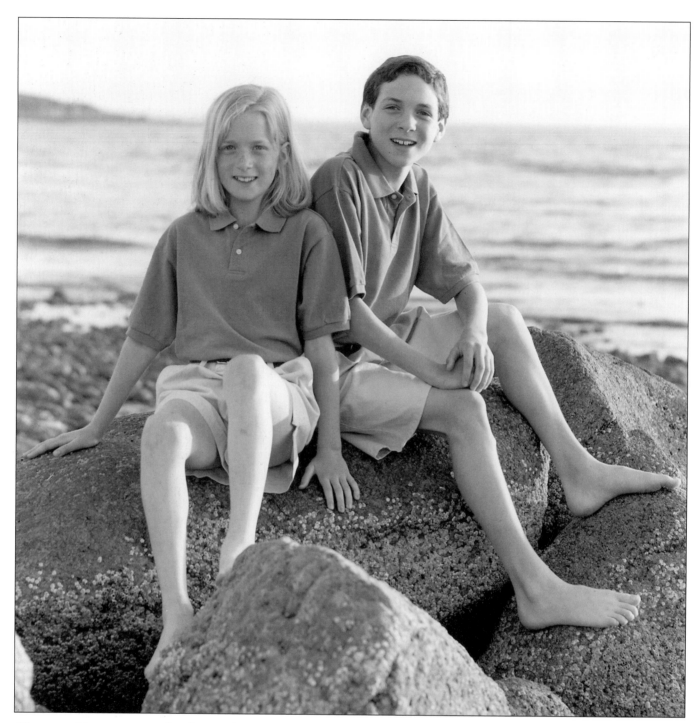

Photographing a teenage brother and sister requires a gentle touch. The parents want to show love, but the children want to look cool. When you are a teenager, touching your opposite sex sibling is definitely not cool! I position the kids as close to each other as possible so they look like they are touching, but there is actually a millimeter of space between them. I tease and cajole them, saying something like, "You won't die if you touch your sister. It can't be that gross! Inch a little closer, you can do it!" I know they love each other. The challenge is getting them to show it!

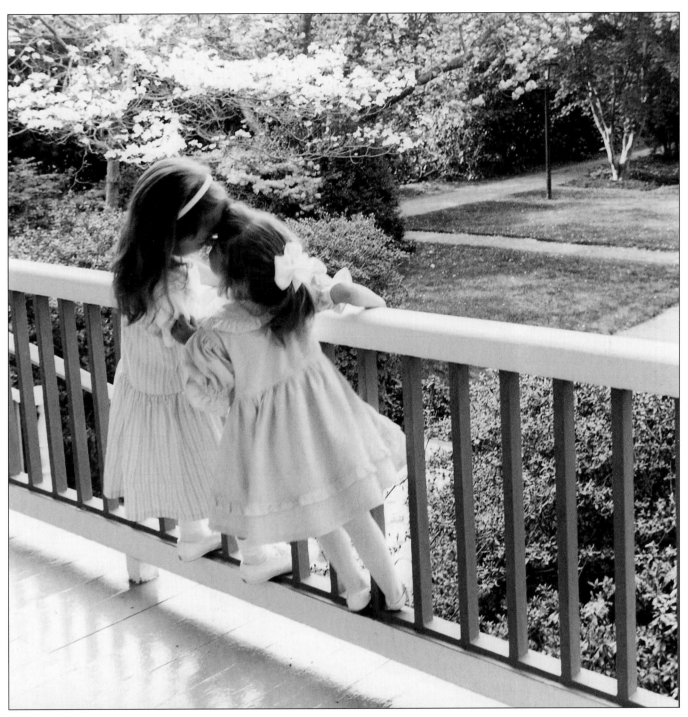

Where brothers can be wild, sisters can be super silly. The girls gave each other "nosey kisses" while I snapped the picture.

Above: Older cousins are the easiest to photograph because they are the most cooperative. I get them involved in the creative process by asking them to help choose the location, prop or background. Of course they wanted to climb on the lifeguard chair! I positioned the girls so each one has a separate sense of space, yet they overlap to show a feeling of closeness.

Right: I love photographing teenagers with younger kids. Teenagers tend to be cool and aloof when they are with other teens, but throw in some younger children and they drop the cool and become children again.

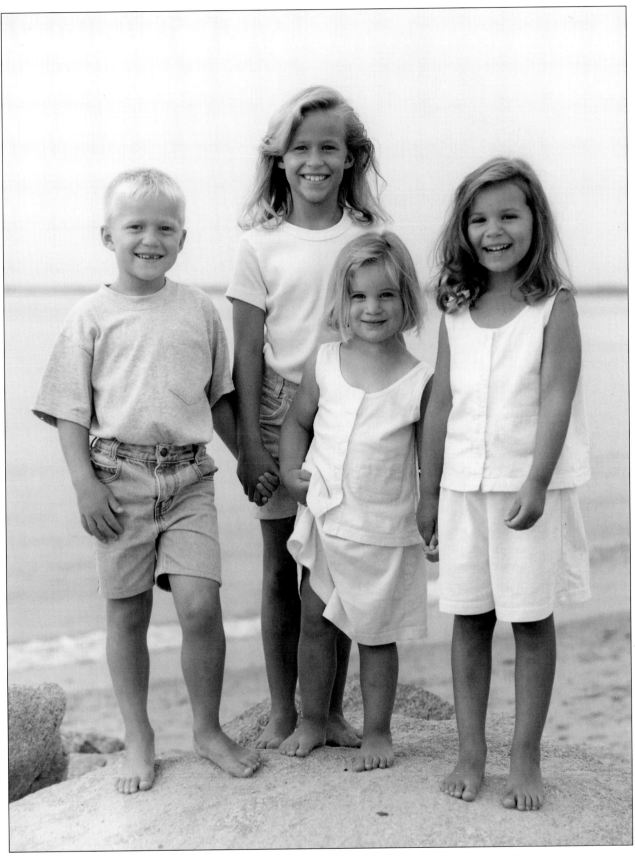

Two pairs of siblings blend to the new relationship called cousins. To keep the individuality within the group, I asked the siblings to hold hands.

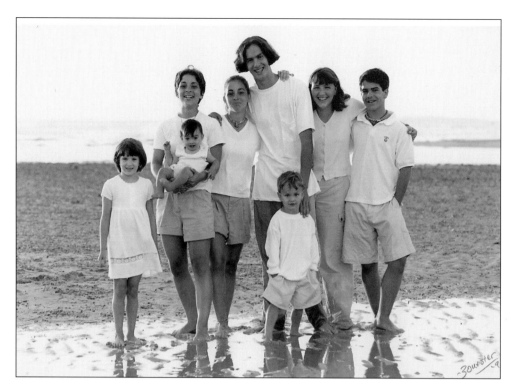

Above: A wide range of ages is actually fairly easy to photograph within one group. The older ones hold the younger ones, and the middle aged children are usually happy to cooperate with whatever the "big kids" are doing.

Right: Young cousins are the hardest to photograph. The three little ones naturally want to bolt the second their feet hit the ground, and the one older cousin can't catch all three. I always look for something I can put the kids up and on to give me a few extra minutes to capture some images. Then I position the oldest child, get my exposure reading and my focus ready, and have the mothers quickly place theirs kids and bolt from the scene. Quick is key! If one mother spends too much time fussing over hair or the outfit, the others are already bored and ready to scramble down. It is important to get something on film before I loose the potentially short attention span of any one of the small kids. Once I've taken a few fast images I will take the time to work on the little details. From that point forward, I feel like we are on "extra credit."

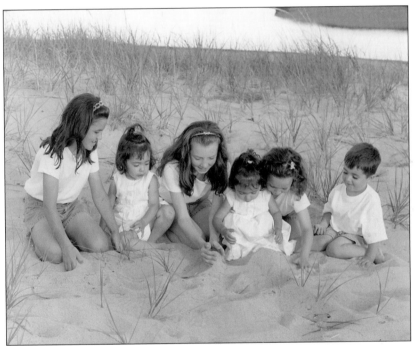

We were having so much trouble getting so many small cousins to look at the camera, we gave up and had them play in the sand. We ("we" includes eight adults) ended up with two neat images.

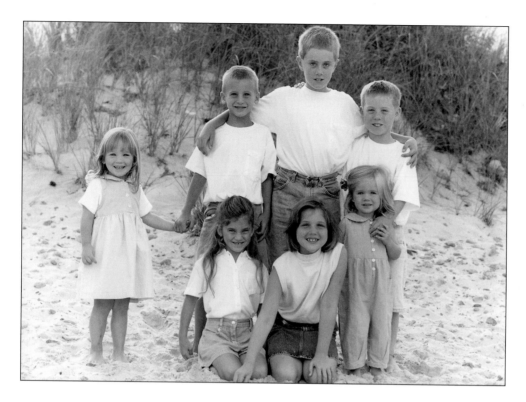

Little refinements make a big difference, even with large groups of cousins. The initial quick images look more posed and formal (above). By asking the kids to give each other a hug, you get a more animated feeling and great expression (right).

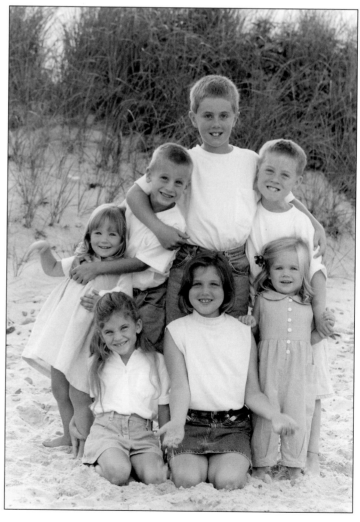

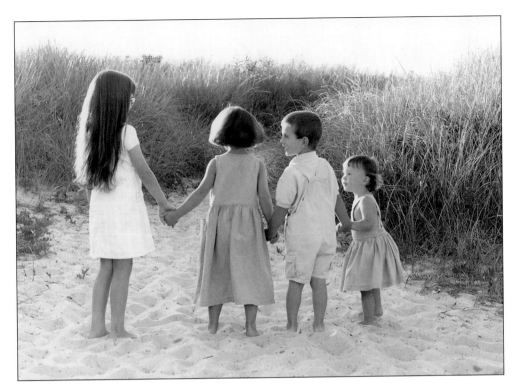

Illustrative images are possible with cousins, but it requires some careful positioning so you can see at least some of their faces. I drew a line on the sand for the children to stand on. Then I asked them to hold hands and look at the oldest while she told them a silly story (above). Although the grandmother specifically requested an image with this illustrative look, I still took a traditional image showing all their faces (right) "just in case."

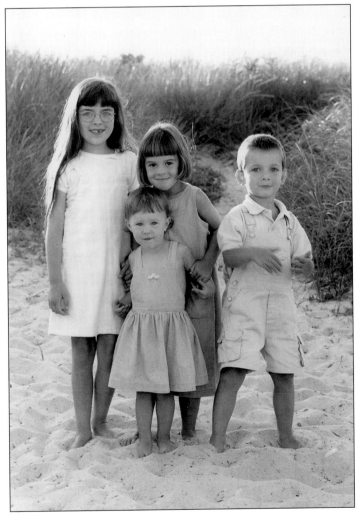

CHAPTER ELEVEN
SOLVING SPECIAL PROBLEMS — TWINS, PETS, HANDICAPPED

Twins, pets and handicapped might seem like an odd combination to include in a chapter about solving special problems, but they share the common denominator of needing extra TLC.

> "...they share the common denominator of needing extra TLC."

Photographing Twins and Groups of Small Siblings

Photographing twins as infants and toddlers requires an extra pair of helping hands during the portrait session.

Since both children need mom simultaneously to get dressed, get combed and get positioned, it works better if mom brings along another relative or close friend to make the session go more smoothly.

If she arrives solo, I will get one twin dressed and ready while she does the other.

Positioning the children is where it makes a big difference to

have the third pair of hands. Small children are often afraid of new situations, including a portrait session. They tend to cling to mom for safety.

When there is an extra adult along that they are comfortable with, the twins are both comforted and distracted (from mom) at the

same time. The helper can position one child while the mother positions the other.

Meanwhile, I can remain at camera angle to take a quick series of images during the split second that both twins are happy and cooperative. Again, the key here is to work fast!

We were walking back to the car when the mother remembered she wanted to do some with the bonnets, but Dad said we had plenty of images already. I did not want to give any opportunity for regret down the road, so I loaded a fresh roll of Tri-X in my RB and did a quick series of images in the patch of clover by the parking lot. The girls were fascinated with the hats and with each other, making a darling addition to their portrait grouping.

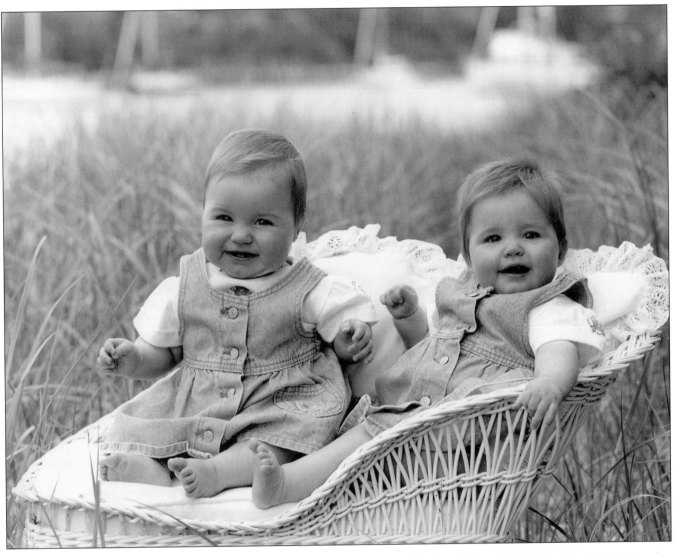

Mom was on the left and dad was on the right to position, wipe away drool and "catch" a baby who decided to wiggle off the bench.

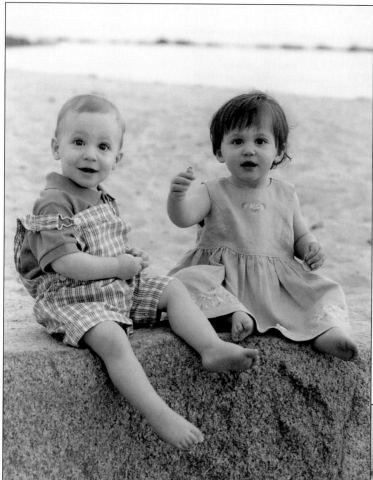

The mother of these twins drove nearly an hour, through torrential downpours, to get to the beach for the late afternoon session. We had to juggle locations because it was raining at the first beach. Needless to say, the pressure was on to get something wonderful before the rain reached our spot. Almost as if the boy sensed our urgency, he was miserable during the majority of the session. Grandma put the daughter in position and mom placed her son on the jetty then crouched below the camera to offer security and encouragement. Once he became interested in the little rocks and shells, he forgot how miserable he was. Their mother said she had never been able to get a photograph where both kids looked cute in the same image, but we created several wonderful images by employing my philosophy of never giving up.

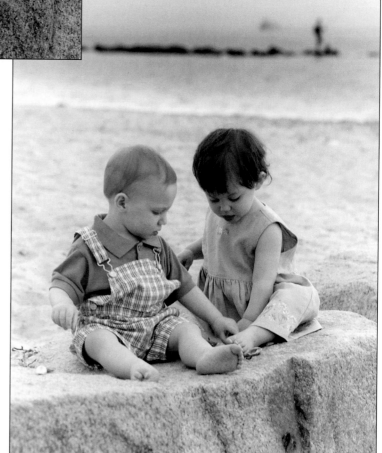

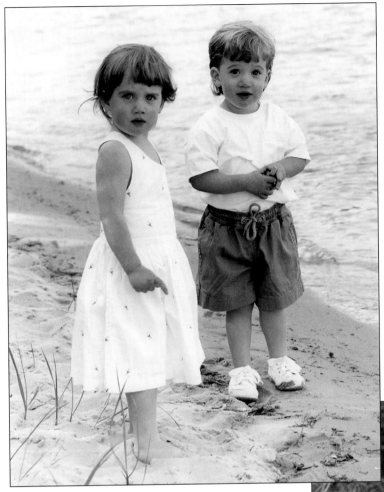

Above: Deliberately posing twin toddlers standing is asking for trouble because they will never stand still. The parents kept running in and out of the image to re-position the children while I kept cranking film through the camera.

Right: Even though there are no twins here, the degree of difficulty shoots to the moon when you photograph three small children. I rarely accept jobs when the children are so close in age and so young unless the parents are going to be photographed too. Including the parents makes the children feel safe. Then, once they are comfortable with the situation, I can usually take some great images without the parents.

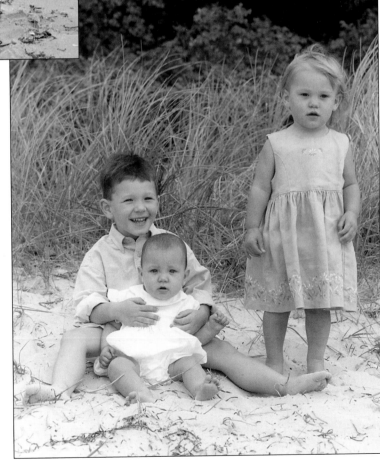

Adding the Family Pet to the Portrait

Dogs and children are a natural combination.

There is a saying, "pets are people too," and when photographing dogs with children it is essentially like adding a two-year-old to the grouping. Of course, some dogs mind better than others, but it is easier to expect the worst and be surprised when you get the best.

I get a strong mental image of how I want the children posed, and then I visualize where the dog will fit the best.

It is the best if one of the children can control the dog, but with smaller children, a parent has to take over that responsibility. Just like when working with a toddler, you must move quickly. For older children, I always position the kids first and add the dog last. If the children are young and restless and the dog is older and well trained, I will position the dog and add the kids around.

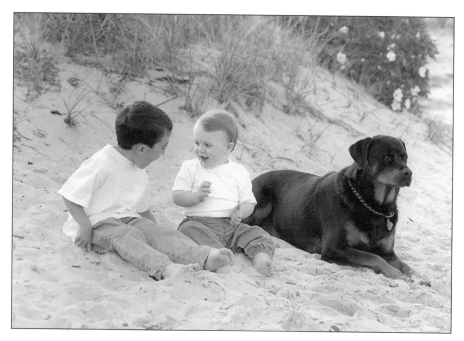

Adding two dogs is equal to adding two toddlers. I ask the children to keep their attention focused on the camera, telling them not to look down at the dogs, "no matter what." Then I make sounds like a cat meowing. Once the dogs have tired of that sound, I try switch to a "woof." Finally, I use my kiddie squeaker to get their attention.

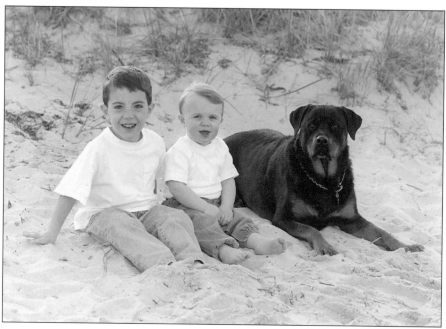

Two small children and one large dog could be very difficult subjects, but this dog was a graduate of an excellent dog obedience school. He did whatever dad said! I love the two different moods portrayed here. The dog protecting his two charges (top) while they are playing carefree beside him. Then, the strength and power created by all three faces looking right to the camera (bottom).

Top: To keep the boys from fighting over their mutual best friend, I positioned the dog right in the middle of all three. They had the shared responsibility of holding the dog.

Bottom: We did a series of more formal portraits of these two, but it was the fun one that captured the relationship of dog and master.

Working with Special Needs Kids

There is a broad definition for handicapped or special needs children. Sometimes parents advise me in advance, and other times I don't find out until I arrive to the photography session.

I do not want to invade their privacy, but I do need to know something of their expectations.

Some mothers are very specific, and others have forgotten that their child looks or acts or responds a little outside of the norm.

"It takes a little more patience and a little more film..."

My overall philosophy is to not treat the child any differently than a "normal" child because who is to say what "normal" really is anyhow!

I try to treat all children like little people, giving them the same attention and respect that I give their parents. I follow the same introduction and greeting procedure with children who have special needs.

It takes a little more patience and a little more film to photograph special needs kids.

Otherwise, they are rarely any more difficult than their "normal" sibling.

When you respect them and reach out to them at the emotional, psychological and physical levels they are able to handle, your efforts will be rewarded every time.

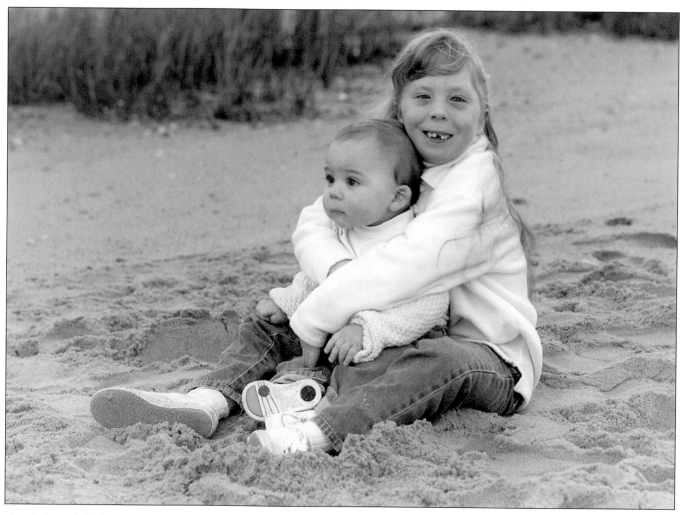

Special needs kids are always amongst the most loving of all the clients I photograph. This little girl runs up and gives me a hug and a kiss every time I see her. That enthusiasm makes the extra time and effort of the portrait session more than worthwhile.

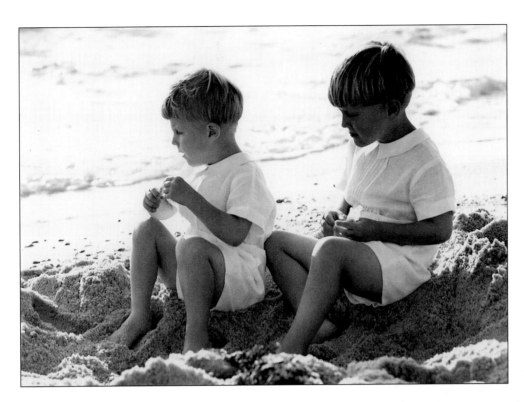

This session was doubly difficult because it combined toddler twins and a handicapped child. One of the twins was born hearing impaired and with most of his right ear missing. The mother asked me to do my best to show the good ear. We had a challenging time juggling them into position. As soon as we got them settled, one would take off running. Again, this is where you cannot quit until you know you have something wonderful. The end results always justify the extra effort. When she sent permission to include her sons' portraits in this book, she added a note that said, "Our pictures fall into the category of 'how to take great pictures of a kid with special needs.' You really captured both our sons."

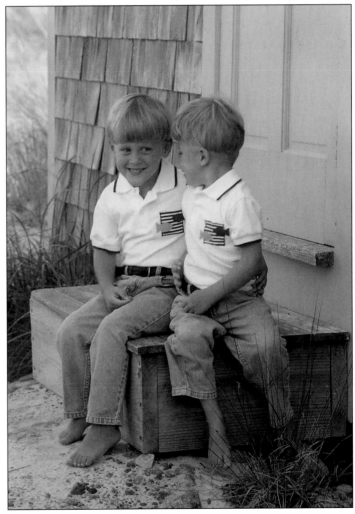

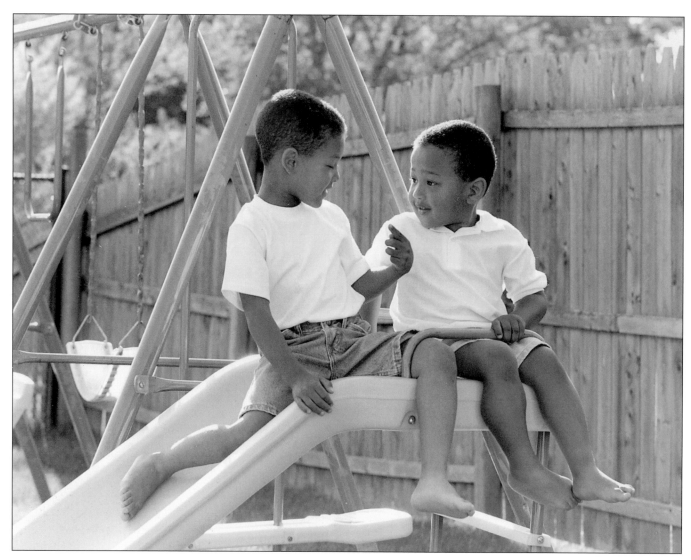

I first photographed the hearing impaired older brother when he was an infant. It is a joy to watch him evolve, learning to sign and read lips. Here, he is telling a story to his little brother. Their mother is off-camera to the right, serving as my language translator.

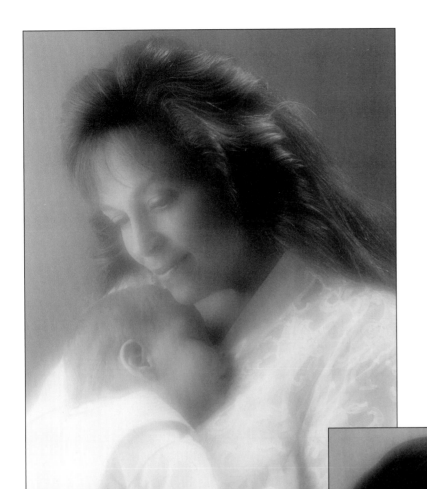

Some special needs kids, like this toddler-aged child who was born with cerebral palsy, just need to be photographed with the nurturing person in their lives, usually mom. One portrait captures the love the mother holds for her son, and the other shows the unquestioned faith the son has for his mother. These black and white images were printed from Kodak VPS II film then hand colored and included in an album collection that included color, black and white and hand colored. Many years later, the mother continues to thank me for hounding her to come in for the traditional mother-child portrait session that she had done with her older son. She said, "Everyone raves about Daniel's portraits. You really captured him and the relationship the two of us continue to share."

APPENDIX

Supplier List

We use the following list of suppliers for assorted wholesale items. Call or write for more information.

OVAL MOUNTS TO MASK OVER SLIDE PROOFS:
Jiffy Mask
The Kinney Company
Box 1229
Mt. Vernon, WA 98273

CANVAS SUPPLIER (MOUNTING AND/OR MATERIALS):
Tara Materials
Box 646 — 111 Fredix Alley
Lawrenceville, GA 30246
(404) 963-5256

BUBBLE WRAP (FOR SHIPPING COMPLETED PORTRAITS):
National Bag
(800) 247-6000

CORRUGATED BOXES/OFFICE SUPPLIES:
Quill Corp.
(800) 789-1331

CHRISTMAS CARDS/STATIONERY FOR PHOTOGRAPHS:
M&M Designs, Inc.
Houston, TX
(713) 461-2600

FRAME CORNERS:
Gemini Moulding Inc.
(800) 323-3575

Larson-Juhl
(800) 438-5031

Gross National Product
(800) 266-4278

CUSTOM CUT MATTING:
Light Impressions
(800) 828-6216

PRE-CUT CUSTOM LOOKING MATTES:
Crescent Cardboard Company
(800) 323-1055

FULL SERVICE B&W LABS:
Filmet
2103 Hampton Street
Pittsburgh, PA 15218

Sound Color
Harbour Pointe Business Center
4711 116th Street, SW
Mukilteo, WA 98275

SPECIALITY B&W CUSTOM LABS:
Jonathan Pennery — Darkroom Services
6 Adelaide Park
Center Moriches, NY 11934
(516) 874-3409

Equipment List

STUDIO EQUIPMENT

- White Lightening with 1200 watt seconds of power for the main light
- Large white soft box—any brand will do
- White Lightening with 1200 watt seconds powered down as needed when used for the background or overhead or fill light
- Small Photogenic silver reflector on a Photogenic light stand with a flexible extender arm
- Calumet light stands for main light and fill light
- Studio tripod on wheels
- Cable release
- Mamiya RB67 camera with 100-200mm zoom lens
- Lindahl shade to easily drop filters in and out
- Nikon One soft focus filter (limited use, mostly on babies)
- Nikon Two soft focus filter (nominal use—for extremely soft images)
- Minolta IV flash meter
- Painted backgrounds
- Muslin drapes
- Assorted posing stools, benches and wicker props

ON LOCATION EQUIPMENT

- Mamiya RB67 camera with 127mm lens for large groups, 180mm lens for small groups
- Hasselblad 503CW with TTL prism and side winder; 120mm and 80mm lenses
- Cable release
- Basic lens shade
- Bendbo tripod
- Pentax Spotmeter V

When you are making your equipment choices, keep in mind my husband's favorite saying on the matter: "People, not cameras, take pictures." Good photographers can create great images with poor equipment, but poor photographers won't become good just by purchasing excellent gear. His second favorite saying is, "The difference between an amateur and a professional is a thousand rolls of film."

Other Publications by Helen T. Boursier

Black & White Portrait Photography
Published by: Amherst Media, Inc.

Family Portrait Photography — Professional Techniques and Images
Published by: Amherst Media, Inc.

Marketing and Selling Black & White Portrait Photography
Published by: Amherst Media, Inc.

The Modern (Hand Tinted) B&W Portrait
Published by: Marathon Publications

The Studio Sales Manual
Published by: Marathon Publications

Marketing Madness
Published by: Marathon Publications

Tell It With Style
Published by: InterVarsity Press

The Cutting Edge
Published by: Boursier Publications

Top Ten Marketing
Published by: Boursier Publications

For information on Helen T. Boursier's current speaking/workshop schedule, contact:
Boursier Publications
FAX: (508) 540-6243

Glossary

Bracketing: Photographing a scene several times, each time changing the exposure by one or two stops, to ensure that one of the exposures is the proper one.

Burning In: Adds more time to the exposure of a specific area of the print in order to darken that area. This is usually achieved by blocking light to the entire print except the area to be burnt. The tool used in this case is a piece of cardboard with a hole cut to approximate the shape of the area in need of more exposure. After the print is exposed, the enlarger light is turned on again. The cut-out blocks the light to the print while allowing exposure to a specific area.

Depth of Field: The area of acceptable sharp focus in a picture. It includes the area in front of and behind the subject that is in focus. Many portrait photographers prefer a shallow depth of field, often just the eyes or the face of the subject to enhance impact.

Dodging In: Holds back light from part of the print in order to brighten that part of the photograph. This is achieved using your hands or pieces of cardboard with wire handles held above the area of the print that needs less exposure. Continuous circular motions during exposure soften the edges of the shadow cast by the dodging tool.

Dragging the Shutter: To allow more light to subtly "wrap" around the subjects when photographing with portable flash units or studio lights, use a lower shutter speed. The aperture on the camera will be correctly set to match the output of the strobe, and the slower shutter speed will allow more time for natural light to fill in around the subjects. This technique does not work with 35mm cameras.

Exposure: The total amount of light allowed to pass through the lens to the film as controlled by the aperture size and the shutter speed.

Film Speed: A film's sensitivity to light, rated numerically. The higher the ASA film speed rating, the faster the film. Faster film requires less light to create exposures on the film.

Filter: A thin sheet of glass, plastic or gelatin placed in front of the camera lens to change the appearance of the image as it is being recorded in the camera.

Halation: A halo-like flare surrounding bright objects on film. Halation is caused by light reflected from the film base.

Handcoloring: Adding color to a black and white photograph by hand with pencils, pastels, watercolors, wet dyes, dry dyes or oils.

Shutter: The camera mechanism that controls the duration of the exposure. A slow shutter speed means the subjects must sit very still or their movement will cause the image to look out of focus and blurred.

Soft Focus: Deliberately diffusing or blurring the definition of an image, usually to create a dreamy or romantic mood.

Index

A

available light 70-79

B

baby portraits 81-83
bracketing exposures 28, 120
broad light 31, 33, 71
burning 57, 120

C

clothing 14, 43
consultation session 42
controlling light 75
cousin portraits 99-105

D

dodging 57, 120

E

element of style 9-12, 35-36
elementary-aged child portraits 84-87
expressions 48-51

F

film selection 25
filter 27

G

group portraits 91-105

H

handling the unexpected 47
Hasselblad 25, 27
high speed film 29-30

I

ideal lighting 70
illustrative portraits 11-12
infrared film 27-29
interfering parents 48, 50

K

Kodak Tmax 3200 TMZ film 30, 73-74
Kodak Tri-X professional film 25-27

L

light meter 56-57, 60
like attracts like 9
locations 34-41

M

Mamiya RB67 25, 27

N

natural light 70

P

parents 48-50
pets 110-111
photographic style 9-24
planning 42-43
Polaroid SX-70 instant film 30-33
pre-planning 11-12
prime time lighting 35

S

Sigma 35mm 27
special needs children portraits 112-115
studio lighting 61-69
style 9, 35-36, 42

T

teenager portraits 88-90
time of session 35, 56, 75
timeless moods 48
toddler portraits 83-84
traditional portraits 9-10
twins portraits 106-109

W

weather 47, 76-79
window light 56-60
windows on location 60

Other Books from
Amherst Media

Basic 35mm Photo Guide, 5th Edition

Craig Alesse

Great for beginning photographers! Designed to teach 35mm basics step-by-step—completely illustrated. Features the latest cameras. Includes: 35mm automatic, semi-automatic cameras, camera handling, *f*-stops, shutter speeds, and more! $12.95 list, 9x8, 112p, 178 photos, order no. 1051.

Build Your Own Home Darkroom

Lista Duren & Will McDonald

This classic book teaches you how to build a high quality, inexpensive darkroom in your basement, spare room, or almost anywhere. Includes valuable information on: darkroom design, woodworking, tools, and more! $17.95 list, 8½x11, 160p, 50 photos, many illustrations, order no. 1092.

Into Your Darkroom Step-by-Step

Dennis P. Curtin

This is the ideal beginning darkroom guide. Easy to follow and fully illustrated each step of the way. Includes information on: the equipment you'll need, setup, making proof sheets and much more! $17.95 list, 8½x11, 90p, hundreds of photos, order no. 1093.

Lighting for People Photography, 2nd Edition

Stephen Crain

The up-to-date guide to lighting for portraiture. Includes: setups, equipment information, strobe and natural lighting, and much more! Features diagrams, illustrations, and exercises for practicing the techniques discussed in each chapter. $29.95 list, 8½x11, 120p, 80 b&w and color photos, glossary, index, order no. 1296.

Camera Maintenance & Repair Book 1

Thomas Tomosy

An illustrated guide by a master camera repair technician. Includes: testing camera functions, general maintenance, basic tools and where to get them, basic repairs for accessories, camera electronics, plus "quick tips" for maintenance and more! $29.95 list, 8½x11, 176p, 100+ photos, order no. 1158.

Camera Maintenance & Repair Book 2

Thomas Tomosy

Build on the basics covered Book 1, with advanced techniques. Includes: mechanical and electronic SLRs, zoom lenses, medium format cameras, and more. Features models not included in Book 1. $29.95 list, 8½x11, 176p, 150+ photos, charts, tables, appendices, index, glossary, order no. 1558.

Restoring the Great Collectible Cameras (1945–70)

Thomas Tomosy

More step-by-step instruction on how to repair collectible cameras. Covers postwar models (1945–70). Hundreds of illustrations show disassembly and repair. $34.95 list, 8½x11, 128p, 200+ photos, index, order no. 1573.

Big Bucks Selling Your Photography 2nd Edition

Cliff Hollenbeck

A completely updated photo business package. Includes starting up, getting pricing, creating successful portfolios and using the internet as a tool! Features setting financial, marketing and creative goals. Organize your business planning, bookkeeping, and taxes. $17.95 list, 8½x11, 128p, 30 photos, b&w, order no. 1177.

Outdoor and Location Portrait Photography 2nd Edition

Jeff Smith

Learn how to work with natural light, select locations, and make clients look their best. Step-by-step discussions and helpful illustrations teach you the techniques you need to shoot outdoor portraits like a pro! $29.95 list, 8½x11, 128p, 60+ full-color photos, index, order no. 1632.

Wedding Photography
CREATIVE TECHNIQUES FOR LIGHTING AND POSING, 2nd Edition

Rick Ferro

Creative techniques for lighting and posing wedding portraits that will set your work apart from the competition. Covers every phase of wedding photography. $29.95 list, 8½x11, 128p, full color photos, index, order no. 1649.

Fashion Model Photography

Billy Pegram

For the photographer interested in shooting commercial model assignments, or working with models to create portfolios. Includes techniques for dramatic composition, posing, selection of clothing, and more! $29.95 list, 8½x11, 120p, 58 photos, index, order no. 1640.

Creating World-Class Photography

Ernst Wildi

Learn how any photographer can create technically flawless photos. Features techniques for eliminating technical flaws in all types of photos—from portraits to landscapes. Includes the Zone System, digital imaging, and much more. $29.95 list, 8½x11, 128p, 120 color photos, index, order no. 1718.

Black & White Portrait Photography

Helen T. Boursier

Make money with b&w portrait photography. Learn from top b&w shooters! Studio and location techniques, with tips on preparing your subjects, selecting settings and wardrobe, lab techniques, and more! $29.95 list, 8½x11, 128p, 130+ photos, index, order no. 1626.

The Beginner's Guide to Pinhole Photography

Jim Shull

Take pictures with a camera you make from stuff you have around the house. Develop and print the results at home! Pinhole photography is fun, inexpensive, educational and challenging. $17.95 list, 8½x11, 80p, 55 photos, charts & diagrams, order no. 1578.

Stock Photography

Ulrike Welsh

This book provides an inside look at the business of stock photography. Explore photographic techniques and business methods that will lead to success shooting stock photos—creating both excellent images and business opportunities. $29.95 list, 8½x11, 120p, 58 photos, index, order no. 1634.

Professional Secrets for Photographing Children
2nd Edition

Douglas Allen Box

Covers every aspect of photographing children on location and in the studio. Prepare children and parents for the shoot, select the right clothes capture a child's personality, and shoot storybook themes. $29.95 list, 8½x11, 128p, 80 full-color photos, index, order no. 1635.

Handcoloring Photographs Step by Step

Sandra Laird & Carey Chambers

Learn to handcolor photographs step-by-step with the new standard in handcoloring reference books. Covers a variety of coloring media and techniques with plenty of colorful photographic examples. $29.95 list, 8½x11, 112p, 100+ color and b&w photos, order no. 1543.

Innovative Techniques for Wedding Photography

David Neil Arndt

Spice up your wedding photography (and attract new clients) with dozens of creative techniques from top-notch professional wedding photographers! $29.95 list, 8½x11, 120p, 60 photos, order no. 1684.

Family Portrait Photography

Helen Boursier

Learn from professionals how to operate a successful portrait studio. Includes: marketing family portraits, advertising, working with clients, posing, lighting, and selection of equipment. Includes images from a variety of top portrait shooters. $29.95 list, 8½x11, 120p, 123 photos, index, order no. 1629.

Wedding Photojournalism

Andy Marcus

Learn the art of creating dramatic unposed wedding portraits. Working through the wedding from start to finish you'll learn where to be, what to look for and how to capture it on film. A hot technique for contemporary wedding albums! $29.95 list, 8½x11, 128p, b&w, over 50 photos, order no. 1656.

Studio Portrait Photography of Children and Babies, *2nd Edition*

Marilyn Sholin

Work with the youngest portrait clients to create cherished images. Includes tips for working with kids at every developmental stage, from infant to preschooler. Features: lighting, posing and much more! $29.95 list, 8½x11, 128p, 90 full-color photos, order no. 1657.

Professional Secrets of Wedding Photography
2nd Edition

Douglas Allen Box

Over fifty top-quality portraits are individually analyzed to teach you the art of professional wedding portraiture. Lighting diagrams, posing information and technical specs are included for every image. $29.95 list, 8½x11, 128p, 60 full-color photos, order no. 1658.

Photo Retouching with Adobe® Photoshop®
2nd Edition
Gwen Lute

Designed for photographers, this manual teaches every phase of the process, from scanning to final output. Learn to restore damaged photos, correct imperfections, create realistic composite images and correct for dazzling color. $29.95 list, 8½x11, 120p, 60+ photos, order no. 1660.

Studio Portrait Photography in Black & White
David Derex

From concept to presentation, you'll learn how to select clothes, create beautiful lighting, prop and pose top-quality black & white portraits in the studio. $29.95 list, 8½x11, 128p, 70 photos, order no. 1689.

Creative Lighting Techniques for Studio Photographers
Dave Montizambert

Master studio lighting and gain complete creative control over your images. Whether you are shooting portraits, cars, tabletop or any other subject, Dave Montizambert teaches you the skills you need to confidently create with light. $29.95 list, 8½x11, 120p, 80+ photos, order no. 1666.

Fine Art Children's Photography
Doris Carol Doyle and Ian Doyle

Learn to create fine art portraits of children in black & white. Included is information on: posing, lighting for studio portraits, shooting on location, clothing selection, working with kids and parents, and much more! $29.95 list, 8½x11, 128p, 60 photos, order no. 1668.

Marketing and Selling Black & White Portrait Photography
Helen T. Boursier

A complete manual for adding b&w portraits to the products you offer clients (or offering exclusively b&w photography). Learn how to attract clients and deliver the portraits that will keep them coming back. $29.95 list, 8½x11, 128p, 50+ photos, order no. 1677.

Profitable Portrait Photography
Roger Berg

A step-by-step guide to making money in portrait photography. Combines information on portrait photography with detailed business plans to form a comprehensive manual for starting or improving your business. $29.95 list, 8½x11, 104p, 100 photos, index, order no. 1570.

Dramatic Black & White Photography
SHOOTING AND DARKROOM TECHNIQUES
J. D. Hayward

Create dramatic fine-art images and portraits with the master b&w techniques in this book. From outstanding lighting techniques to top-notch, creative darkroom work, this book takes b&w to the next level! $29.95 list, 8½x11, 128p, order no. 1687.

Posing and Lighting Techniques for Studio Photographers
J. J. Allen

Master the skills you need to create beautiful lighting for portraits of any subject. Posing techniques for flattering, classic images help turn every portrait into a work of art. $29.95 list, 8½x11, 120p, 125 full-color photos, order no. 1697.

Watercolor Portrait Photography
THE ART OF POLAROID SX-70 MANIPULATION
Helen T. Boursier

Create one-of-a-kind images with this surprisingly easy artistic technique. Boursier walks readers through the photo manipulation process and offers tips on selecting a setting, composing the image and more. $29.95 list, 8½x11, 128p, 200+ color photos, order no. 1698.

Techniques for Black & White Photography
CREATIVITY AND DESIGN
Roger Fremier

Harness your creativity and improve your photographic design with these techniques and exercises. From shooting to editing your results, it's a complete course for photographers who want to be more creative. $19.95 list, 8½x11, 112p, 30 photos, order no. 1699.

Corrective Lighting and Posing Techniques for Portrait Photographers
Jeff Smith

Learn to make every client look his or her best by using lighting and posing to conceal real or imagined flaws—from baldness, to acne, to figure flaws with this indispensible book. $29.95 list, 8½x11, 120p, full color, 150 photos, order no. 1711.

Basic Digital Photography

Ron Eggers

Step-by-step text and clear explanations teach you how to select and use all types of digital cameras. Learn all the basics with no-nonsense, easy to follow text designed to bring even true novices up to speed quickly and easily. $17.95 list, 8½x11, 80p, 40 b&w photos, order no. 1701.

Professional Secrets of Natural Light Portrait Photography

Douglas Allen Box

Learn to utilize natural light to create inexpensive and hassle-free portraiture. Beautifully illustrated with detailed instructions on equipment, setting selection and posing. $29.95 list, 8½x11, 128p, 80 full-color photos, order no. 1706.

Portrait Photographer's Handbook

Bill Hurter

Bill Hurter has compiled a step-by-step guide to portraiture that easily leads the reader through all phases of portrait photography. This book will be an asset to experienced photographers and beginners alike. $29.95 list, 8½x11, 128p, full color, 60 photos, order no. 1708.

Professional Marketing & Selling Techniques for Wedding Photographers

Jeff Hawkins and Kathleen Hawkins

Learn the business of successful wedding photography. Includes consultations, direct mail, print advertising, internet marketing and much more. $29.95 list, 8½x11, 128p, 80 photos, order no. 1712.

Photographers and Their Studios

CREATING AN EFFICIENT AND PROFITABLE WORKSPACE

Helen T. Boursier

Tour the studios of working professionals, and learn their creative solutions for common problems, as well as how they optimized their studios for maximum sales. $29.95 list, 8½x11, 128p, 100 photos, order no. 1713.

Photographing Creative Landscapes

Michael Orton

Boost your creativity and bring a new level of enthusiasm to your images of the landscape. This step-by-step guide is the key to escaping from your creative rut and beginning to create more expressive images. $29.95 list, 8½x11, 128p, 70 photos, order no. 1714.

Advanced Infrared Photography Handbook

Laurie White Hayball

Building on the techniques covered in her *Infrared Photography Handbook*, Laurie White Hayball presents advanced techniques for harnessing the beauty of infrared light on film. $29.95 list, 8½x11, 128p, 100 photos, order no. 1715.

Picture-Taking for Moms & Dads

Ron Nichols

Anyone can push a button and take a picture. It takes more to create a portrait that will be treasured for years to come. With this book, moms and dads will learn how to achieve great results—with any camera! $12.95 list, 6x9, 80p, 50 photos, order no. 1717.

Zone System

Brian Lav

Learn to create perfectly exposed black & white negatives and top-quality prints. With this step-by-step guide, anyone can learn the Zone System and gain complete control of their black & white images! $29.95 list, 8½x11, 128p, 70 photos, order no. 1720.

Selecting and Using Classic Cameras

Michael Levy

Discover the charms and challenges of using classic cameras. Folders, TLRs, SLRs, Polaroids, rangefinders, spy cameras and more are included in this gem for classic camera lovers. $17.95 list, 6x9, 196p, 90 photos, order no. 1719.

Traditional Photographic Effects with Adobe® Photoshop®

Michelle Perkins and Paul Grant

Use Photoshop to enhance your photos with handcoloring, vignettes, soft focus and much more. Every technique contains step-by-step instructions for easy learning. $29.95 list, 8½x11, 128p, 150 photos, order no. 1721.

Master Posing Guide for Portrait Photographers

J. D. Wacker

Learn the techniques you need to pose single portrait subjects, couples and groups for studio or location portraits. Includes techniques for photographing weddings, teams, children, special events and much more. $29.95 list, 8½x11, 128p, 80 photos, order no. 1722.

Photographic Lenses
PHOTOGRAPHER'S GUIDE TO CHARACTERISTICS, QUALITY, USE AND DESIGN
Ernst Wildi

Gain a complete understanding of the lenses through which all photographs are made—both on film and in digital photography. $29.95 list, 8½x11, 128p, 70 photos, order no. 1723.

The Art of Color Infrared Photography
Steven H. Begleiter

Color infrared photography will open the doors to an entirely new and exciting photographic world. This exhaustive book shows readers how to previsualize the scene and get the results they want. $29.95 list, 8½x11, 128p, 80 full-color photos, order no. 1728.

The Art of Photographing Water
Cub Kahn

Learn how to capture the dynamic interplay of light and water with this beautiful, compelling and comprehensive book. Packed with practical information you can use right away! $29.95 list, 8½x11, 128p, 70 full-color photos, order no. 1724.

High Impact Portrait Photography
Lori Brystan

Learn how to create the high-end, fashion-inspired portraits your clients will love. Features posing, alternative processing and much more. $29.95 list, 8½x11, 128p, 60 full-color photos, order no. 1725.

Legal Handbook for Photographers
Bert P. Krages, Esq.

This book offers tangible examples that illustrate the *who, what, when, where* and *why* of permissible and problematic subject matter, putting photographers at ease to shoot—without fear of liability. $19.95 list, 8½x11, 128p, 40 b&w photos, order no. 1726.

Digital Imaging for the Underwater Photographer
Jack and Sue Drafahl

This book will teach readers how to improve their underwater images with digital imaging techniques. This book covers all the bases—from color balancing your monitor, to scanning, to output and storage. $39.95 list, 6x9, 224p, 80 color photos, order no. 1727.

How to Take Great Pet Pictures
Ron Nichols

From selecting film and equipment to delving into animal behavior, Nichols teaches all that beginners need to know to take well-composed, well-exposed photos of these "family members" that will be cherished for years. $14.95 list, 6x9, 80p, 40 full-color photos, order no. 1729.

The Art of Bridal Portrait Photography
Marty Seefer

Learn to give every client your best and create timeless images that are sure to become family heirlooms. Seefer takes readers through every step of the bridal shoot, ensuring flawless results. $29.95 list, 8½x11, 128p, 70 full-color photos, order no. 1730.

Photographer's Filter Handbook
Stan Sholik and Ron Eggers

Take control of your photography with the tips offered in this book! Readers will learn how to color-balance images, correct contrast problems, create special effects and more. $29.95 list, 8½x11, 128p, 100 full-color photos, order no. 1731.

Beginner's Guide to Adobe® Photoshop®
Michelle Perkins

Learn the skills you need to effectively make your images look their best, create original artwork or add unique effects to almost any image. All topics are presented in short, easy-to-digest sections that will boost confidence and ensure outstanding images. $29.95 list, 8½x11, 128p, 150 full-color photos, order no. 1732.

Professional Techniques for Digital Wedding Photography
Jeff Hawkins and Kathleen Hawkins

From selecting the right equipment to building an efficient digital workflow, this book teaches how to best make digital tools and marketing techniques work for you. $29.95 list, 8½x11, 128p, 80 full-color photos, order no. 1735.

Lighting Techniques for High Key Portrait Photography
Norman Phillips

From studio to location shots, this book shows readers how to meet the challenges of high key portrait photography to produce images their clients will adore. $29.95 list, 8½x11, 128p, 100 full-color photos, order no. 1736.

Beginner's Guide to Digital Imaging

Rob Sheppard

Learn how to select and use digital technologies that will lend excitement and provide increased control over your images—whether you prefer digital capture or film photography. $29.95 list, 8½x11, 128p, 80 full-color photos, order no. 1738.

Lighting and Exposure Techniques for Outdoor and Location Portrait Photography

J. J. Allen

Learn to counterbalance the challenges of changing light and complex settings with easy-to-use techniques that help you achieve great images every time. $29.95 list, 8½x11, 128p, 150 full-color photos, order no. 1741.

Photographer's Lighting Handbook

Lou Jacobs Jr.

Think you need a room full of expensive lighting equipment to get great shots? This book explains how light affects every subject you shoot and how, with a few simple techniques, you can produce the images you desire. $29.95 list, 8½x11, 128p, 130 full-color photos, order no. 1737.

Professional Digital Photography

Dave Montizambert

From monitor calibration, to color balancing and advanced artistic effects, this book provides photographers skilled in basic digital imaging with the techniques they need to take their photography to the next level. $29.95 list, 8½x11, 128p, 120 full-color photos, order no. 1739.

Photographer's Guide to Polaroid Transfer, *2nd Edition*

Christopher Grey

Step-by-step instructions make it easy to master Polaroid transfer and emulsion lift-off techniques and add new dimensions to your photographic imaging. Fully illustrated to ensure great results the first time! $29.95 list, 8½x11, 128p, 50 full-color photos, order no. 1653.

Professional Secrets of Nature Photography

Judy Holmes

Improve your nature photography with this must-have book. Covers all aspects of making top-quality images, from selecting the right equipment, to choosing the best subjects, to shooting techniques for professional results every time. $29.95 list, 8½x11, 120p, 100 color photos, order no. 1682.

Group Portrait Photographer's Handbook

Bill Hurter

With images by over twenty of the industry's top portrait photographers, this indispensible book offers timeless tips for composing, lighting and posing dynamic group portraits. $29.95 list, 8½x11, 128p, 120 full-color photos, order no. 1740.

Toning Techniques for Photographic Prints

Richard Newman

Whether you want to age an image, provide a shock of color, or lend archival stability to your black & white prints, the step-by-step instructions in this book will help you realize your creative vision. $29.95 list, 8½x11, 128p, 150 full-color/b&w photos, order no. 1742.

The Art and Business of High School Senior Portrait Photography

Ellie Vayo

Learn the techniques that have made Ellie Vayo's studio one of the most profitable senior portrait businesses in the United States. Covers advertising design, customer service skills, clothing selection, and more. $29.95 list, 8½x11, 128p, 100 full-color photos, order no. 1743.

The Best of Nature Photography

Jenni Bidner and Meleda Wegner

How do legendary nature photographers like Jim Zuckerman and John Sexton create their captivating images? Follow in their footsteps as these and other top photog-raphers capture the beauty and drama of nature on film. $29.95 list, 8½x11, 128p, 150 full-color photos, order no. 1744.

Storytelling Wedding Photography

Barbara Box

Barbara and her husband shoot as a team at weddings. Here, she shows you how to create outstanding candids (which are her specialty), and combine them with formal portraits (her husband's specialty) to create a unique wedding album. $29.95 list, 8½x11, 128p, 60 b&w photos, order no. 1667.

Photographing Children with Special Needs

Karen Dórame

This book explains the symptoms of spina bifida, autism, cerebral palsy and more, teaching photographers how to safely and effectively capture the unique personalities of these children. $29.95 list, 8½x11, 128p, 100 full-color photos, order no. 1749.

Beginner's Guide to Nature Photography

Cub Kahn

Whether you prefer a walk through a neighborhood park or a hike through the wilderness, the beauty of nature is ever present. Learn to create images that capture the scene as you remember it with the simple techniques found in this book. $14.95 list, 6x9, 96p, 70 full-color photos, order no. 1745.

Innovative Techniques for Wedding Photography

David Neil Arndt

Spice up your wedding photography (and attract new clients) with dozens of creative techniques from top-notch professional wedding photographers! $29.95 list, 8½x11, 120p, 60 photos, order no. 1684.

Composition Techniques from a Master Photographer

Ernst Wildi

In photography, composition can make the difference between dull and dazzling. Master photographer Ernst Wildi teaches you his techniques for evaluating subjects and composing powerful images in this beautiful full-color book. $29.95 list, 8½x11, 128p, 100+ full-color photos, order no. 1685.

Photo Salvage with Adobe® Photoshop®

Jack and Sue Drafahl

This indispensible book will teach you how to digitally restore faded images, correct exposure and color balance problems and processing errors, eliminate scratches and much, much more. $29.95 list, 8½x11, 128p, 200 full-color photos, order no. 1751.

The Art of Black & White Portrait Photography

Oscar Lozoya

Learn how master photographer Oscar Lozoya uses unique sets and engaging poses to create black & white portraits that are infused with drama. Includes lighting strategies, special shooting techniques and more. $29.95 list, 8½x11, 128p, 100 full-color photos, order no. 1746.

The Best of Wedding Photography

Bill Hurter

Learn how the top wedding photographers in the industry transform special moments into lasting romantic treasures with the posing, lighting, album design and customer service pointers found in this book. $29.95 list, 8½x11, 128p, 150 full-color photos, order no. 1747.

Success in Portrait Photography

Jeff Smith

No photographer goes into business expecting to fail, but many realize too late that camera skills alone do not ensure success. This book will teach photographers how to run savvy marketing campaigns, attract clients and provide top-notch customer service. $29.95 list, 8½x11, 128p, 100 full-color photos, order no. 1748.

Professional Digital Portrait Photography

Jeff Smith

Digital portrait photography offers a number of advantages. Yet, because the learning curve is so steep, making the tradition to digital can be frustrating. Author Jeff Smith shows readers how to shoot, edit and retouch their images—while avoiding common pitfalls. $29.95 list, 8½x11, 128p, 100 full-color photos, order no. 1750.

The Best of Children's Portrait Photography

Bill Hurter

See how award-winning photographers capture the magic of childhood. *Rangefinder* editor Bill Hurter draws upon the experience and work of top professional photographers, uncovering the creative and technical skills they use to create their magical portraits. $29.95 list, 8½x11, 128p, 150 full-color photos, order no. 1752.

More Photo Books Are Available

Contact us for a FREE catalog:

AMHERST MEDIA
PO BOX 586
AMHERST, NY 14226 USA

www.AmherstMedia.com

Ordering & Sales Information:

INDIVIDUALS: If possible, purchase books from an Amherst Media retailer. Write to us for the dealer nearest you. To order direct, send a check or money order with a note listing the books you want and your shipping address; Visa and MasterCard are also accepted. For domestic and international shipping rates, please visit our web site or contact us at the numbers listed below. New York state residents add 8% sales tax.

DEALERS, DISTRIBUTORS & COLLEGES: Write, call or fax to place orders. For price information, contact Amherst Media or an Amherst Media sales representative. Net 30 days.

1(800)622-3278 or (716)874-4450
FAX: (716)874-4508

All prices, publication dates, and specifications are subject to change without notice.
Prices are in U.S. dollars. Payment in U.S. funds only.